POSTCARD HISTORY SERIES

Ventura

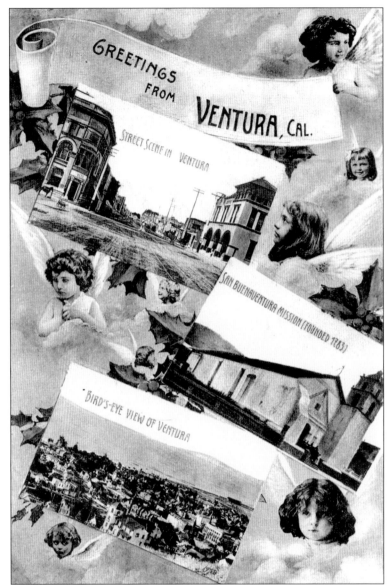

This early 1900s postcard shows different views of Ventura. A typical promotional item used at that time, these cards carried the same art but swapped out town names and images. (Courtesy Cynthia Thompson.)

FRONT COVER: This fantastic bird's-eye view of Ventura looks east from California and Main Streets. In the lower left-hand corner is a tombstone business, and next to that is the old newspaper building. Judge Ewing's house, pictured above center, is located at Chestnut and Poli Street and is still standing today. To the right is Elizabeth Bard Memorial Hospital. (Courtesy Cynthia Thompson.)

BACK COVER: The stagecoach was a terrific marketing program for Wheeler's Hot Springs near Nordhoff. Passengers arrived at the Ventura Depot and hopped on the stagecoach for the sometimes two-hour drive. This June 18, 1906, postcard reads, "Came to Ventura (from Ojai) on Wheelers Stage and ran around Ventura for two hours and took the stage home. Didn't enjoy the stage ride very much, will take the train next time." At one time, a steam train ran between Ojai and the Ventura Avenue area.

POSTCARD HISTORY SERIES

Ventura

Glenda J. Jackson

ARCADIA

Published by Arcadia Publishing
Charleston SC, Chicago IL, Portsmouth NH, San Francisco CA

Printed in Great Britain

Library of Congress Catalog Card Number: 2005929110

For all general information contact Arcadia Publishing at:
Telephone 843-853-2070
Fax 843-853-0044
E-mail sales@arcadiapublishing.com
For customer service and orders:
Toll-Free 1-888-313-2665

Visit us on the Internet at www.arcadiapublishing.com

This book is dedicated to my children, Lyra and Noel, my grandchildren, Jesse and Julian, my mother, Betty, and my father, Billy Glen.

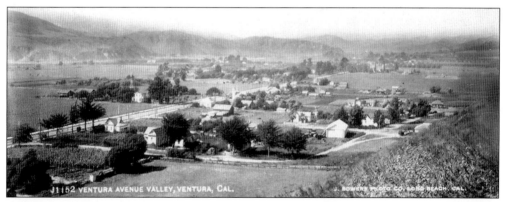

On October 19, 1872, the *Ventura Signal* paid this compliment: "No more beautiful place (naturally) can be found in the State than Ventura Valley. It begins with Main Street and runs due north along the east bank of the Ventura River four miles, with an average width of one mile. When its long, straight alameda shall be widened 14 feet, and lined fully, as it now is partially, with evergreens, there will be no handsomer drive in the State. It already contains some very pretty cottages and gardens, and is being cut up and bought up for residences. A. D. Barnard has sold three tracts within the past ten days, all of which will be handsomely improved. He still has some 60 acres of the most desirable part of the tract left, which he is offering on easy terms."

CONTENTS

ACKNOWLEDGMENTS

I have many people to thank for helping me make this book a reality: Shawna Atchison, for trusting me with her cards for several months; John Burgman for giving me unlimited access to his card collection; Michel Colmache, manager of the El Patio Hotel, for giving me the postcard; Richard D. Dean for his encouragement and scans; UC Davis for the scans of Theodosia Burr Shepherd; Charles Johnson of the Ventura County Museum of History and Art, for always patiently answering my emails and taking my many phone calls; Suzanne Lawrence, who shared so many wonderful stories of Ventura and inspired me to become a storyteller; Jeff Maulhardt, for inviting me over, scanning the images for the cover, and for use of the early courthouse card; Dena Mercer, for sharing her family's wonderful photographs; Ken Prag, who has the most awesome cards I've ever bought; San Buenaventura Heritage, Inc., for the image of the Dudley House; Richard Senate, who encouraged me in 1997 to do that first historical walking tour and for so openly sharing his history of Ventura with me; Cynthia Thompson of Authentic Resources Team, for her images and information on the Pierpont Inn; and to Julie Tumamait, a Chumash descendant, for her information and assistance.

INTRODUCTION

San Buenaventura, the *City of Good Fortune*, now known as Ventura, was founded on March 31, 1782, by Fr. Junipero Serra. But our history goes back centuries earlier to its first inhabitants, the Chumash Indians. Peaceful and very skilled at basket weaving and rock painting, the Chumash lived in villages of thatched huts near the Ventura beach and called this area Shisholop. They were hunter-gatherers, dependent on natural resources for their food and shelter, traveling between the mainland and the Channel Islands in 25-foot-long Tomols (plank canoes).

Portuguese navigator Juan Rodriguez Cabrillo, sailing under the flag of Spain, wrote about the Chumash in October 1542, when he anchored off the coast near San Buenaventura. He spent nearly six weeks traveling around the islands and was very impressed with the number of Chumash Indians and their friendliness. His pilot Ferrel noted, "We saw on the land a village of Indians near the sea, and the houses large in the manner of New Spain; and they have anchored in front of a very large valley on the coast. Here came to the ships many very good canoes which held in each one twelve or thirteen Indians . . . They go covered in the skins of animals; they are fishers and eat the fish raw." On November 11, 1542, Cabrillo fell and broke his arm on San Miguel Island. The ship's doctor splinted the arm and wrapped it in a sling, and Cabrillo thought little more of it. The expedition continued north toward Monterey but encountered a heavy storm and turned back. By the time the fleet arrived at San Miguel's Cuyler Harbor on November 23, gangrene had set into Cabrillo's improperly healed arm. He died on January 3, 1543, and was buried on the island. After 400 years of earthquakes and rock slides, it is thought that his burial site is now beneath many thousands of tons of earth.

With the founding of Mission San Buenaventura, the lives of the Chumash changed forever. Twenty-three Spanish missions were built along the California coast, with conversion of the Indians the first order of business. The local Chumash were forced into mission life, and their language and customs were obliterated. Disease brought by the Europeans decimated the local population. The decline of the Chumash continued with the secularization of the missions. Today there is a resurgence of interest in Chumash culture and heritage, and many descendants still call Ventura their home.

On March 10, 1866, Ventura incorporated as a city, but growth was very slow. The wharf was not built until 1872, and the railroad didn't steam into town until 1887. Before this, getting to Ventura required a great amount of determination, as there were two rivers to cross—the mighty Santa Clara on the east and the Ventura on the west—and that was only during low tide or the dry season. Or if you didn't want to get your feet wet, you could travel up and over the Casitas Pass from Santa Barbara—not exactly a walk in the park, since the mode of travel was by

bumpy stagecoach. And in its earliest days, Ventura was segregated, with Indian Town near the Ventura River, Spanish Town below Front Street (where Tortilla Flats once stood, now home to Seaside Park), and the American section.

Strolling around Ventura's quaint downtown historical district today, it is hard to imagine dirt roads, wooden sidewalks, cattle drives, saloons, a Chinatown, and a couple of houses of ill repute. Or that each September, until 1873, Ventura's Spanish heritage was celebrated on San Miguel Day with a real live bullfight held in Plaza de Toros, near the corner of Main Street and Ventura Avenue.

With the wharf and coming of the railroad, Ventura began to grow rapidly, as more people discovered the town. And like so many cities, the old gave way to the new. Just thumbing through the *Ventura Souvenir Centennial Publication 1866–1966,* you realize that many old buildings were still standing a mere 40 years ago. But back then, there was no historic preservation—no push to preserve our past. Many of these historic buildings and houses were bulldozed to make way for modern structures. The old adobes are gone, except for the Ortega and the Olivas. The Schiappapietra Mansion on Santa Clara Street was bulldozed in the 1950s to put up a parking lot. The town's cemetery was turned into a park, and now people play frisbee above the graves of 2,000 people. The train depot was torn down in 1973. More recently, the 1950s Ban Dar was razed. Then we lost the historic Magnolia Tree. The Mayfair Theatre went from beautiful landmark to an eyesore. As efforts were underway to restore it, the building burned down. And sadly, in August, vandals burned down the historic Saticoy Chapel.

Today people are becoming more aware of the importance of historic preservation, but it takes many people working together to preserve a town's rich history. Ventura has a story to tell; you just have to listen. Then you'll know just what our founding fathers knew: Ventura really is the City of Good Fortune.

We are people to whom the past is forever speaking. We listen to it because we cannot help ourselves, for the past speaks to us with many voices. Far out of that dark nowhere which is the time before we were born, men who were flesh of our flesh and bone of our bone went through fire and storm to break a path to the future. We are part of the future they died for; they are part of the past that brought the future. What they did—the lives they lived, the sacrifices they made, the stories they told and the songs they sang and, finally, the deaths they died—make up a part of our own experience. We cannot cut ourselves off from it. It is as real to us as something that happened last week. It is a basic part of our heritage as Americans.

—Author unknown

One

1782

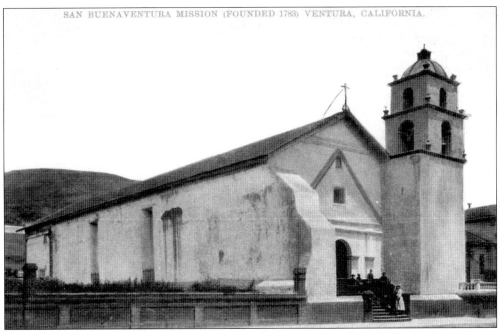

SAN BUENAVENTURA MISSION (FOUNDED 1783) VENTURA, CALIFORNIA.

Mission San Buenaventura, named for St. Bonaventura, was originally to be the third mission in a series of 21 California missions. But by the time it was founded on March 31, 1782, it became the ninth. The current church on Main Street was completed in 1809 but damaged by an earthquake in 1812. Repair and renovations were completed in 1815 and included the large buttresses on the front of the building. The Arnaz family is pictured on the steps in the mid-1860s.

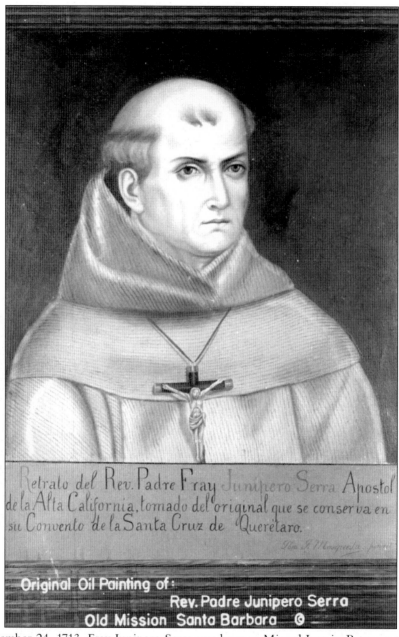

Original Oil Painting of:
Rev. Padre Junipero Serra
Old Mission Santa Barbara ©

On November 24, 1713, Fray Junipero Serra was born as Miguel Jose in Petra on the Island of Majorca. He took the name Junipero upon his Franciscan confirmation. In 1749, he went to Mexico City, and in 1768, he accompanied Gaspar de Portola on an expedition into Upper California. In 1769, he founded Mission San Diego. While in Mexico, Father Serra injured his leg, and by the time he had walked to San Buenaventura, it had become ulcerated and he was in ill health. Arriving in San Buenaventura, a simple *enramada* of boughs and a small wooden cross was erected to celebrate mass. The exact location is unknown but is thought to have been near the ocean not from the San Miguel Chapel site on Thompson Boulevard. Father Serra stayed at the mission site for only three weeks before he headed to Santa Barbara. On August 28, 1784, he died at Mission San Carlos.

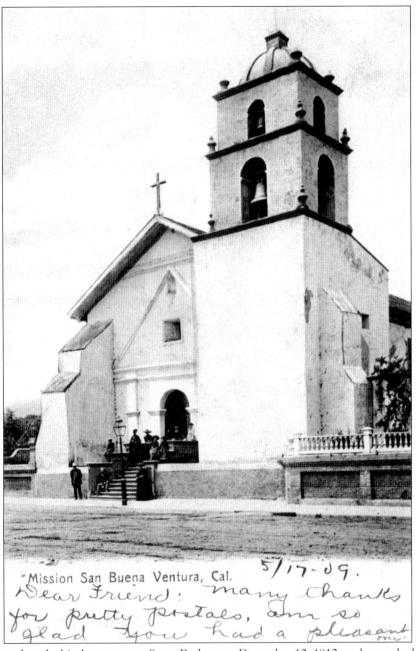

"Mission San Buena Ventura, Cal. 5/17-09.

Dear Friend: many thanks for pretty postals, am so glad you had a pleasant over

A large earthquake hit the coast near Santa Barbara on December 12, 1812, and severely damaged the new mission. It also created a 50-foot-tall tidal wave that reached halfway up present-day California Street. Aftershocks rocked the area for months, and the padres and Chumash Indians abandoned the mission and set up temporary quarters near Casitas Pass (Highway 33 and Cañada Larga Road), close to the Canet Ranch. The Santa Gertrudis Chapel was established here between 1804 and 1808, with small houses built for the neophytes—hence the name Casitas, or "small houses" in Spanish. Mass was held there for several months until the aftershocks and fear of tidal waves subsided. The site of the Santa Gertrudis Chapel lies beneath Highway 33. (Courtesy John Burgman.)

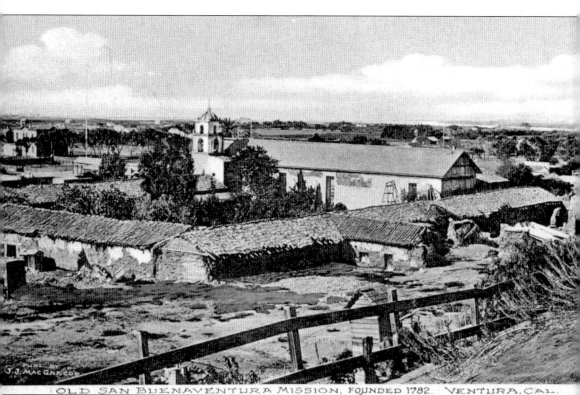

OLD SAN BUENAVENTURA MISSION, FOUNDED 1782. VENTURA, CAL.

This 1880s image shows one of the three quadrangles that enclosed the gardens and fountains at the San Buenaventura Mission. In the foreground, barely visible beyond the fence, are the wine and olive presses. Records from 1825 show the mission having 37,000 head of cattle, 600 head of horses, 200 yoke of working oxen, 500 muñles, 30,000 sheep, and 200 goats. The orchard produced pears, apples, peaches, figs, apricots, nectarines, and dates. English walnut trees also stood in the orchard, and some of the first oranges in California were grown here. Grapes were plentiful and sweet and were made into wine or dried as a kind of raisin. The mission grounds extended from Main Street south to Meta Street (Thompson Boulevard) and from Ventura Avenue to just west of Palm Street.

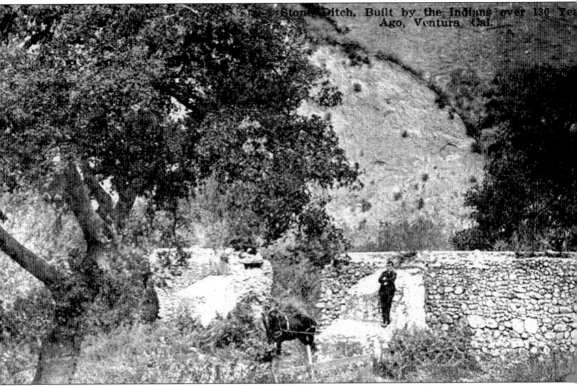

This card's message, dated August 6, 1909, reads, "I believe you would enjoy California. Your 'horse' would come in handy here." This is the largest remaining segment of the mission's aqueduct on present day Cañada Larga Road off Highway 33. To supply water to the mission, a seven-mile-long aqueduct was built from San Antonio Creek below Oakview to the mission. Constructed of local river rock, the aqueduct was based on Roman aqueduct principals and snaked along the foothills, jumping creeks, and barrancas. Water flowed to the El Caballo filtration tank, named for its horse-head spout, in present-day Eastwood Park, off Poli Street. Water was purified for drinking and also diverted to the orchards and several lavanderias for washing clothes. The aqueduct was in use until the 1860s, when flooding destroyed major portions of it. The original reservoir still exists behind the mission. El Caballo was at one time used as the town jail. The large gap in the aqueduct shown on the postcard was dynamited by a local farmer to create a road.

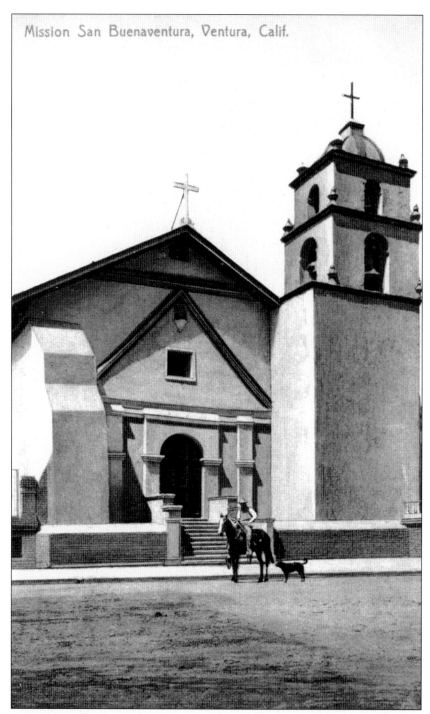

Mission San Buenaventura, Ventura, Calif.

The November 16, 1872, issue of the *Ventura Signal* stated that the "Mission orchard and garden that has lain intact for nearly a century, has been ordered to 'move on,' so we are informed, and will be streeted and lotted in due time. This is a most sensible move. Now a little timely work on that venerable yet beautiful edifice, the Mission Building and the church, will have inaugurated a good work and an example that will be quickly followed by other improvements."

PALMS AT VENTURA, CAL.

(7066)

COURTESY OF
MR. J.C. BREWSTER

"To the south in a lot on Colombo Street is the one remaining palm of the grove of more than 300 trees once planted as an orchard." In 1901, the Native Daughters of the Golden West preserved these last remnants of the gardens. These stately palms stood on land now occupied by the Ventura County Museum of History and Art. Records show that there were three palms, then two, and by 1957, when the mission celebrated its 150th anniversary, only one palm remained. That, too, finally succumbed to the ravages of time.

"Just a line to let you know I am visiting Ventura today. Drove up this morning. I am getting hungry, it is about noon. Wish you could see me eat. Ventura is a lovely place. With love, Lulu. August 9, 1907." This image shows Mission Palms Park located on Colombo Street, a short-lived street only one block long that ran between Main and Santa Clara Streets.

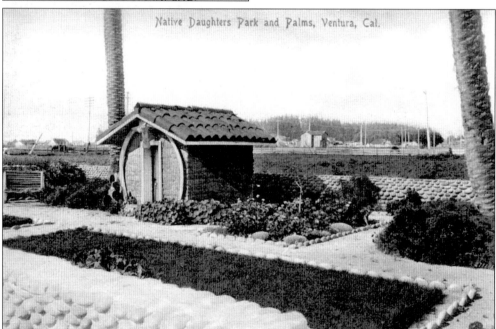

In 1886, as remnants of the mission quadrangle were being torn down, Dr. Stephen Bowers obtained adobe bricks and roof tiles and built this small building on his property at Oak and Santa Clara Streets. In 1906, it was moved to Colombo Street near the last two remaining palm trees. The building served as a reminder of the days of the mission and the Chumash who helped build it.

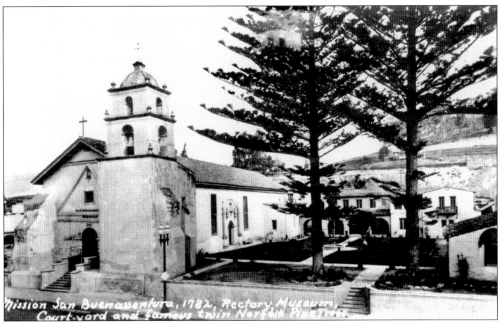

These two large Norfolk pine trees were planted around 1880. There are several stories surrounding their planting. With the wharf built in 1872, one story says they were landmarks for ocean navigation. Another story says that a sea captain planted them to use as replacement masts for his ship in case he needed them, but he never returned. Which story is accurate is anyone's guess. (Courtesy Shawna Atchison.)

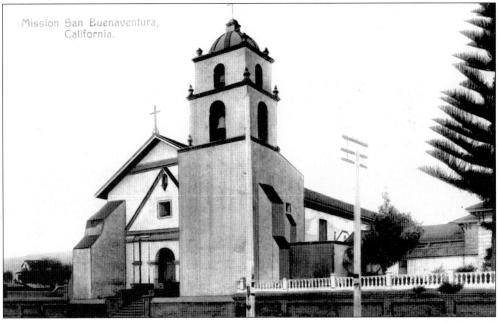

The description on this card, written July 12, 1908, says, "Mission San Buenaventura is situated in a beautiful stretch of land, south of Santa Barbara and north of Los Angeles. The buildings are in a good state of preservation today and services are held regularly as of old. The Church is finely decorated."

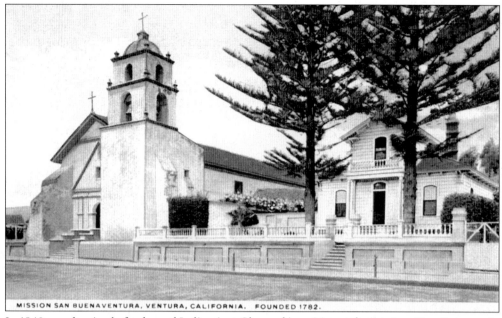

MISSION SAN BUENAVENTURA, VENTURA, CALIFORNIA. FOUNDED 1782.

In 1840, word arrived of a planned Indian (not Chumash) uprising at the mission. Don Raymundo Olivas, a member of the military, was posted to defend it against the Indians. As they rushed up for the attack, Olivas stabbed the chief in the neck, and the Indians scattered. After mustering out, Olivas and his wife, Teodora, built the Olivas Adobe on nearly 5,000 acres near the Santa Clara River. Today it is a historic museum on Olivas Park Drive. This postcard shows the old rectory, which was eventually torn down.

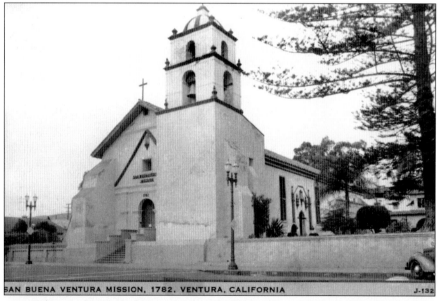

SAN BUENA VENTURA MISSION, 1782, VENTURA, CALIFORNIA J-132

Written on February 25, 1945, this postcard reads, "Dear Niece Margaret: Donnie and me could see the Christmas tree (Norfolk Pine Tree) above the rectory buildings in our room at the hotel. Your mother saw this when here." A tradition started many decades ago is the lighting of these trees during the holiday season. After a lapse of a few years, due to budget constraints, lights once again brighten the downtown.

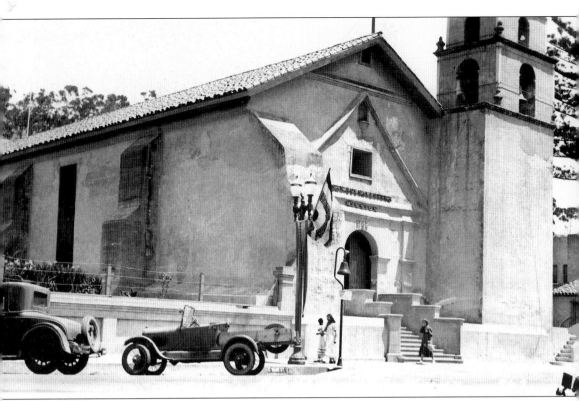

In 1912, Edith Hobson wrote, "The exterior of the church has undergone little change except that the entrance terrace and iron gates were removed when some person in a spirit of thoughtless progressiveness believed that Main Street should be straightened at any cost." (Courtesy John Burgman.)

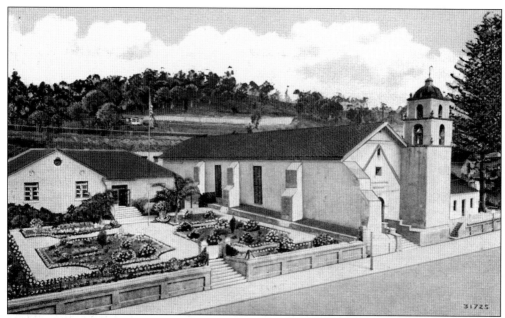

The first burial ground lay west of the mission, where the gardens are depicted in this postcard. During the nearly 90 years it was used as a cemetery, almost 4,000 bodies were buried there. Chumash Indians were wrapped in tule mats, and Spaniards were reportedly buried in wooden coffins. Adult burials ceased in 1861, although burial of infants continued until 1873. The gardens gave way to a parking lot. The bodies have never been moved.

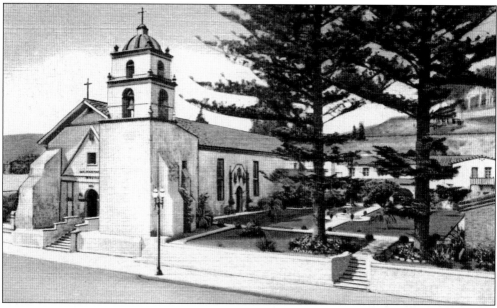

In 1818, word reached the mission that Bouchard the Pirate was on his way from Monterey to ransack and pillage. The padres and Chumash Indians gathered relics, money, and treasure and headed for the hills, burying everything. Bouchard never landed in Ventura, but tales of buried treasure still abound today. This view shows the gardens east of the church. The old rectory is gone and the current wall not yet built.

From 1866 to the 1920s, some 200 Chinese lived in this small section of Figueroa Street with businesses, laundries, rooming houses, a barber shop, and Joss house. Plagued by discrimination, the Chinese (out of necessity) formed a fire brigade and always arrived at fires before the town's own fire company. By the early 1900s, many of the residents began moving out of Chinatown, eventually owning and operating successful local businesses. Chinatown disappeared in the 1920s. (Courtesy Dena Mercer.)

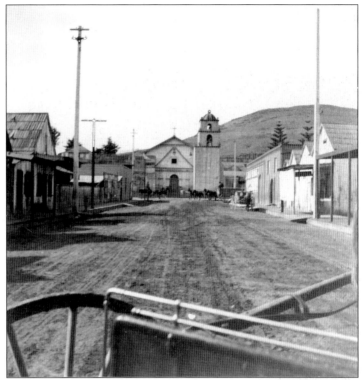

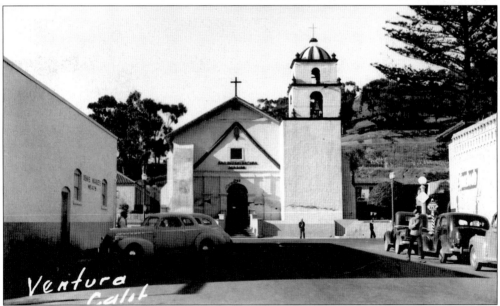

This image shows Figueroa Street in the 1940s. On the left is Dennis Market, and on the right is Peirano's Market, constructed in the 1870s as Ventura's first commercial brick building. Originally Gandolfo's, it became Peirano's when Nick Peirano took over in 1890. The market remained in the family for nearly 100 years. In 1992, a mission-era lavanderia was discovered under the building and covered over to preserve it. The market is now an upscale restaurant, Jonathan's at Peirano's.

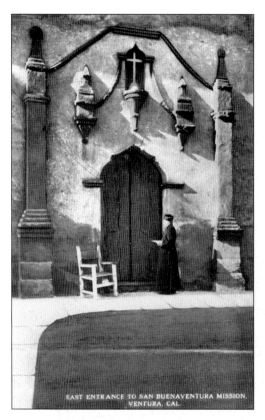

EAST ENTRANCE TO SAN BUENAVENTURA MISSION, VENTURA, CAL.

Designed in a Moorish style, the side church doors are carved with the "river of life" symbols. Above the doorway, the two lines that intersect at the small statue represent the Ventura and Santa Clara Rivers; the line at the top represents the hillside above the mission. This was a simple map for the Chumash to use to find their way back to the mission.

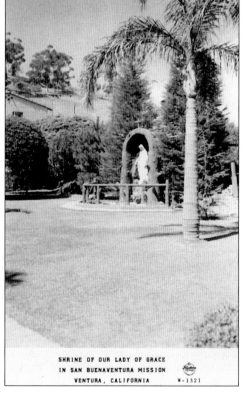

SHRINE OF OUR LADY OF GRACE IN SAN BUENAVENTURA MISSION VENTURA, CALIFORNIA W-1321

"This is sure a wonderful trip. I am enjoying it every minute. We really have a lot of fun. We stayed at a lovely place last night. I have to pinch myself every once and a while and see if it really is me. I needed this rest so bad I was all in. Love, Bertha, June 13, 1948." The Shrine of Our Lady of Grace still stands in the courtyard. (Courtesy Shawna Atchison.)

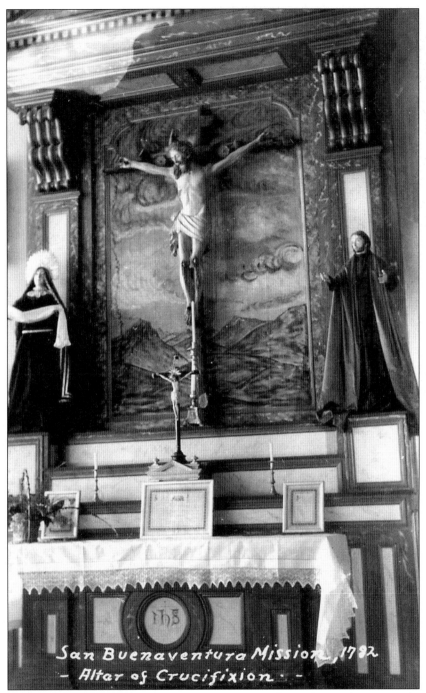

San Buenaventura Mission, 1792
- Altar of Crucifixion -

Dating back to the 1870s, the interior of the mission has changed several times. Father Rubio began what he called "restoration" by putting in new flooring and covering up the beautiful tile floor of the Chumash Indians. He also covered up frescoes and ceiling work that the Chumash had done by hand. In 1897, Father Grogan succeeded Father Rubio and took greater care with the old relics. Many are now on display in the mission museum, and sections of the old beautiful tile floor have been uncovered inside San Buenaventura Mission.

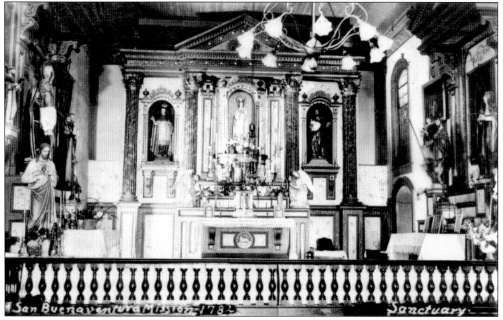

San Buenaventura Mission 1782. Sanctuary.

"Formerly the ceiling was composed of rough hewn timbers just as they were cut from the forest with the marks of the ax upon them. On the right wall near the altar was a beautiful carved pulpit up to which steps led from the floor. The beautiful high altar was built in the City of Mexico while the pictures, it is said, were painted in Peru or Spain," wrote Edith Hobson in 1912. (Courtesy Shawna Atchison.)

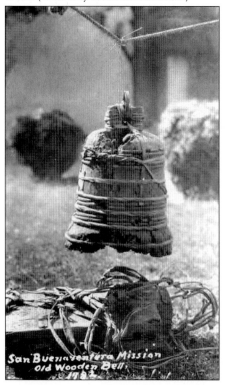

San Buenaventura Mission Old Wooden Bell. 1782.

The mission's wooden bells have been a mystery for over 100 years. Originally there were three, but one fell from the bell tower and was destroyed. The remaining bells, now housed in the museum, are carved mahogany made of two wooden halves held together by wooden butterfly fasteners and wrapped with rawhide straps. Evidence shows the bells were never fitted with clappers. The most recent explanation is that they were made to hang in the belfry until the metal bells arrived to replace them.

24

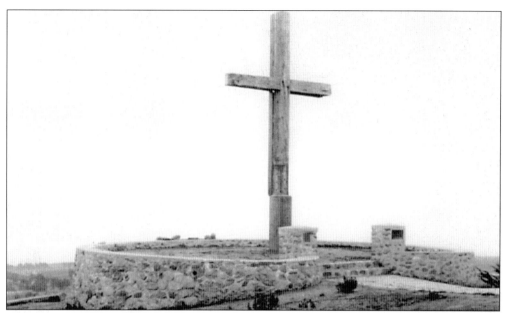

There have been several crosses on top of the hill (Grant Park) above the mission. The original is thought to have been erected in 1782 as a landmark for travelers finding their way to the mission. It was lost and a replacement put up in the 1860s, which blew down in 1875 and was replaced on Admission Day, September 8, 1912, by the ECO, a ladies service organization. It was replaced yet again in 1938. (Courtesy John Burgman.)

The back of this postcard reads, "Dear Ken: This is on top of a great big hill. It sure is a beautiful view from up there. Love, Shirley." For years, the cross has been a favorite spot for sightseers and lovers. At night, the cross was always lit and could be seen by travelers on Highway 101.

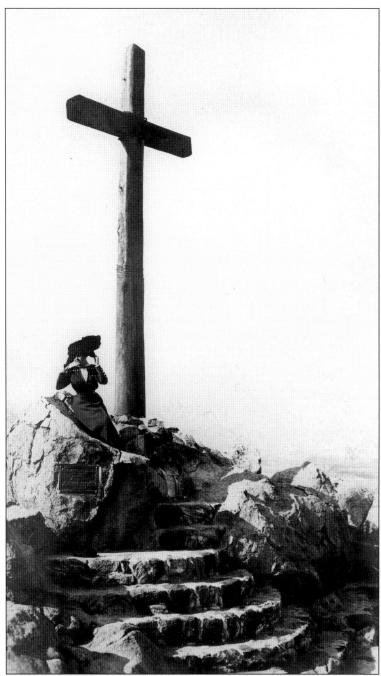

This is a 1913 photograph of Mae Mercer at the cross. In 2003, the historic cross was threatened by a potential lawsuit that charged violation of separation of church and state due to the City of San Buenaventura's ownership and maintenance. Similar lawsuits in other communities had resulted in those cities being forced by the courts to divest themselves of their crosses. The Ventura City Council voted on July 31, 2003, to sell the cross and an acre of land surrounding it to the highest bidder. On September 22, 2003, the Grant Park Cross was sold to San Buenaventura Heritage, Inc. for $104,216.87. (Courtesy Dena Mercer.)

Two

BIRD'S-EYE VIEWS

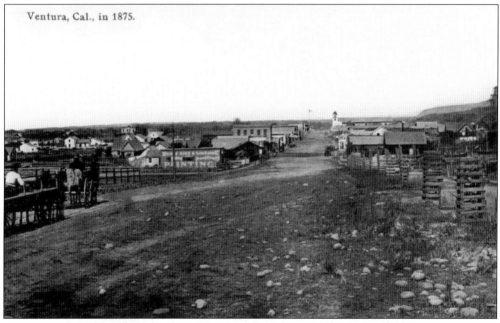

Ventura, Cal., in 1875.

According to the *San Francisco Chronicle,* "San Buenaventura, the town with the beautiful name, is thirty miles below Santa Barbara. The *Ventura Signal* sounds it praises and our remembrances of this seaside nook, with its quaint and curious old church, single street, palm or two, gardens and ocean beach, delightful climate and sea breezes, justify all that is said in its praise." A rebuttal from the *Ventura Signal* on January 4, 1873, however, had this to say, "The town with the beautiful name doffs its sombrero and begs that the *Chronicle* and all other newspapers drop the 'San Buena' and call us by the simple, beautiful name—Ventura. 'Its single street' is not correct, as there are many; strange enough for a California town, they are laid out 'square with the world,' east and west, north and south. 'Palm tree or two' is good, but we stick for three and bet they are the biggest Arabian date palms in the United States." This 1875 image shows Main Street from Fir looking west toward the mission. Ladder-like structures at right were built around newly planted trees for protection from cattle routinely driven down the street.

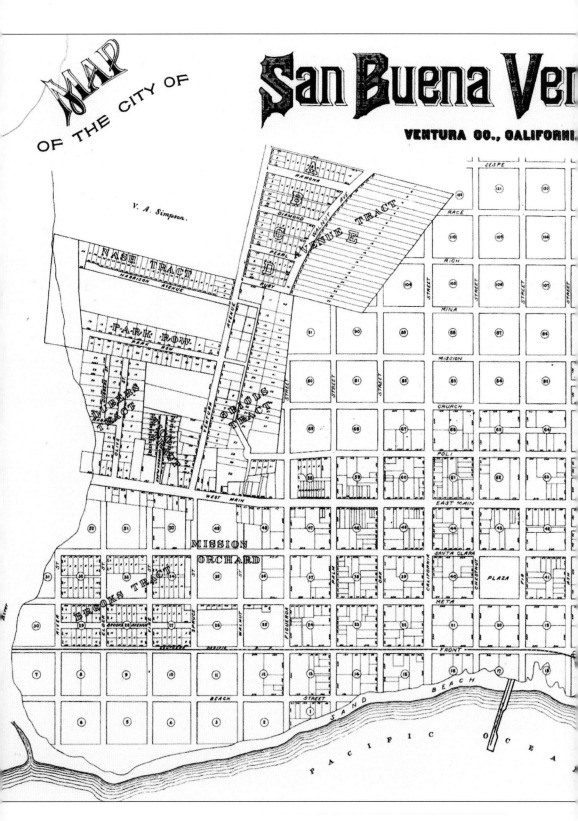

MAP
OF THE CITY OF
San Buena Ven
VENTURA CO., CALIFORNI

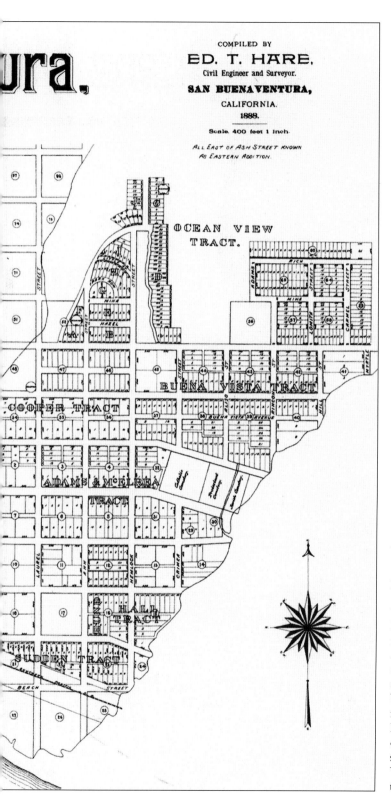

ura.

COMPILED BY

ED. T. HARE,

Civil Engineer and Surveyor.

SAN BUENAVENTURA,

CALIFORNIA.

1888.

Scale, 400 feet 1 inch.

ALL EAST OF ASH STREET KNOWN AS EASTERN ADDITION.

OCEAN VIEW TRACT.

BUENA VISTA TRACT

COOPER TRACT

ADAMS & McELREA TRACT.

HALL TRACT

SUDDEN TRACT

This 1888 map of Ventura shows many of the old streets near present-day Seaside Park (all are gone). At one time, it was a thriving Hispanic community named Tortilla Flats. A mural honoring this community was painted along Figueroa Street, but removed, amidst much public outcry. Note that the mission orchard grounds were still much a part of the Ventura community at that time.

29

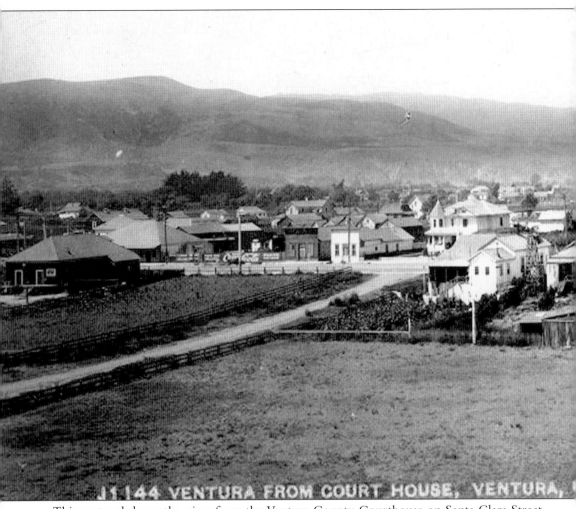

JI.I44 VENTURA FROM COURT HOUSE, VENTURA,

This postcard shows the view from the Ventura County Courthouse on Santa Clara Street. The Ventura County Museum of History and Art and Mission Plaza Park are now located in this area. To the right, Colombo Street is visible, with the two palms original to the mission

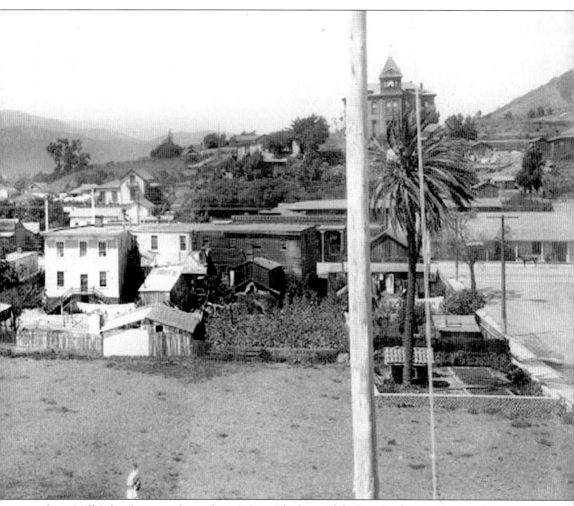

gardens. Hill School towers above the mission. The beautiful Victorian homes dotting this area have long since been razed, themselves having replaced the old adobe homes that once graced this part of town.

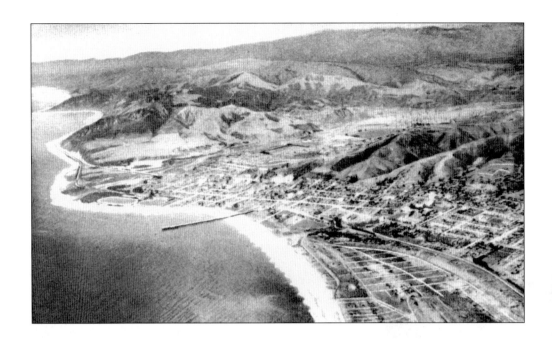

These two cards show different views of the Ventura coastline. The image above shows Ventura, looking north toward Santa Barbara. The postcard below shows a view of Ventura from the cross at Grant Park, looking toward Oxnard.

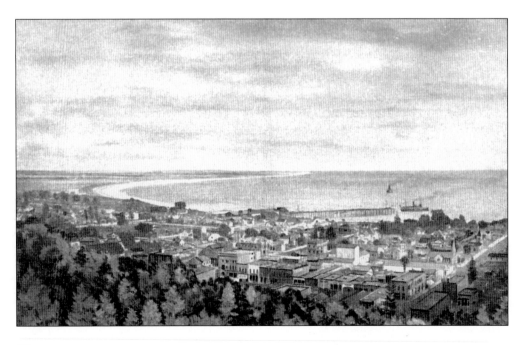

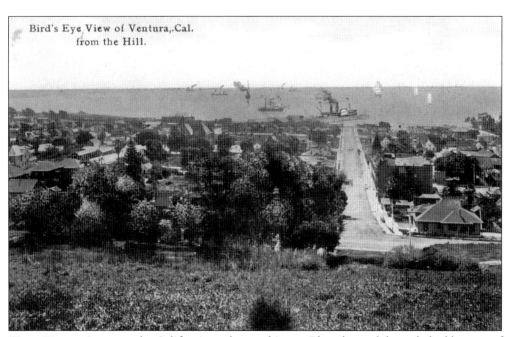

Bird's Eye View of Ventura, Cal. from the Hill.

"Dear Warren, Saw a regular California sandstorm this a.m. Blew the sand through double panes of glass. That's going some. Charles. January. 20, 1908." Looking straight down California Street toward the ocean, it must have been a remarkable site to see vessels docking alongside the Ventura Wharf.

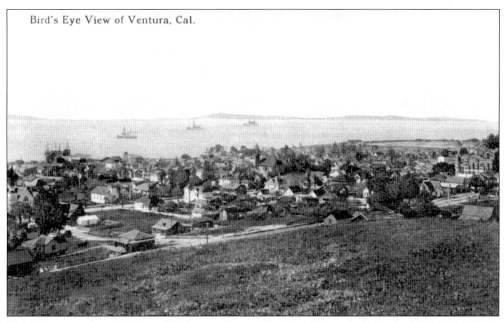

Bird's Eye View of Ventura, Cal.

This view was taken just east of Kalorama Street. The Hotel Rose, built in the 1880s, is visible at the right of the card. The *Ventura Weekly Democrat,* on April 27, 1906, read, "The old (wooden) sidewalks on Oak Street, between Main and Poli, are being taken up and cement sidewalks substituted. It would add materially to the appearance and value of sidewalks in some parts of the town to be similarly treated."

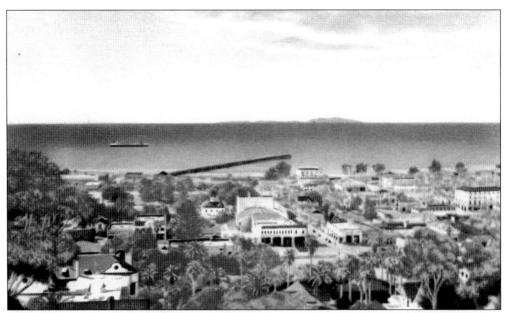

Over the years, many photographs have been taken from the vantage point of Grant Park. On a clear day, the view of the entire coastline is unobstructed, making this a favorite spot for visitors and picnickers. Years ago, a former resident in his eighties returned to Ventura for a visit and recalled that, as a boy, he fell down the hill below Grant Park into a hidden cave filled with Chumash artifacts.

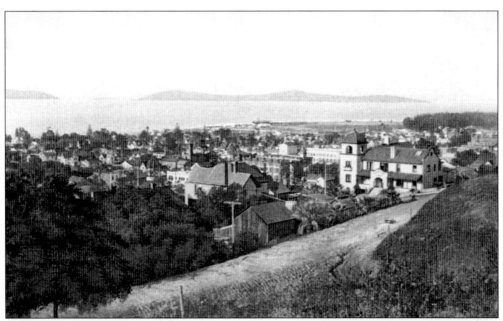

The prominent Bard Hospital is clearly seen in this view taken from the vicinity of present-day Buena Vista Street. The channel between Ventura and the Islands was called "The Devil's Jaws" by local Chumash. The water is notoriously dangerous and can go from dead calm to white caps in a matter of minutes, as evidenced by the hundreds of shipwrecks littering the ocean floor. (Courtesy Cynthia Thompson.)

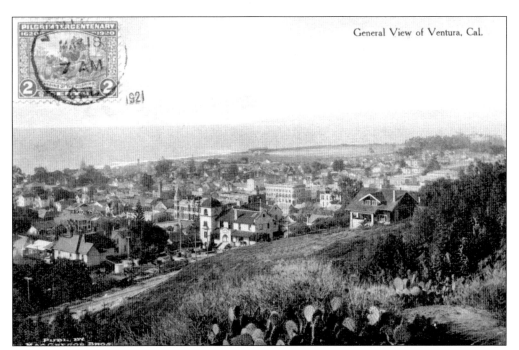

The author of this 1921 postcard wrote the following: "Dear Sir, The Kosmopolitan Club have failed to list me as a protected member and I am being swamped with cards contrary even to my wishes and worthless due to error on part of Club Manager. You will remember my letter to you relative to my requests. If impossible to be protected please cancel my membership."

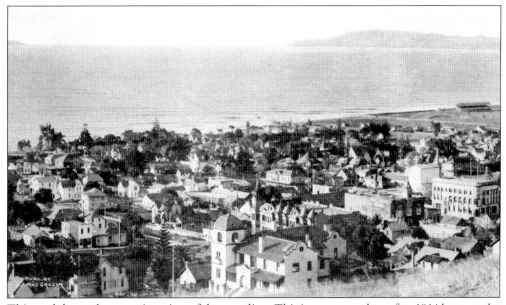

This card shows the sweeping vista of the coastline. This image was taken after 1914 because the viewing stands are seen at the newly constructed Seaside Park along the shoreline. The Hotel Rose and the IOOF clock tower are also visible.

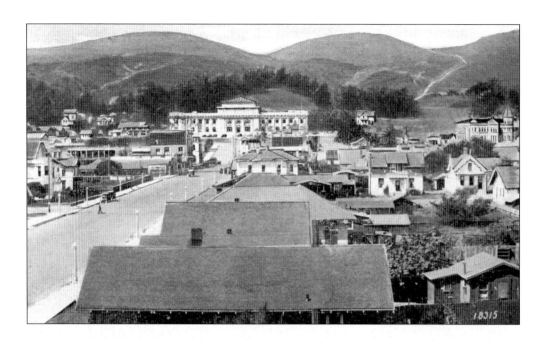

The above image shows the new Ventura County Courthouse at the top of California Street. In the early days, California Street had many homes south of Santa Clara Street. The card below shows a slighter closer view. The only remaining homes on California Street are two Victorian houses—one belonging to Congressman Vandever, Ventura County's first congressman, and now a business office. The other home was owned by Dr. T. E. Cunnane, the town's physician after the death of Dr. Bard, now also a business office.

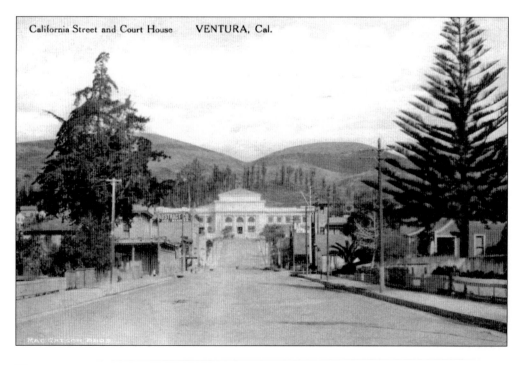

California Street and Court House VENTURA, Cal.

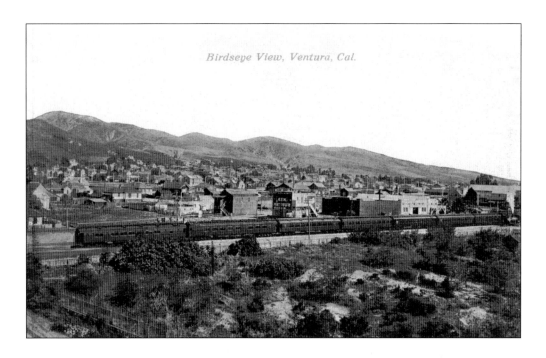

Birdseye View, Ventura, Cal.

These two cards were originally part of one panoramic photograph taken below Front Street and looking to the hillsides of Ventura. Today there are four cards that collectors vie for. Front Street originally extended all the way to Figueroa Street, but disappeared after the construction of Seaside Park. The street to the right of the large holding tank is Kalorama Street. Many lumber yards cropped up along Front Street due to its proximity to the Ventura Wharf. The hardest card to find of these four is called "The Wharf."

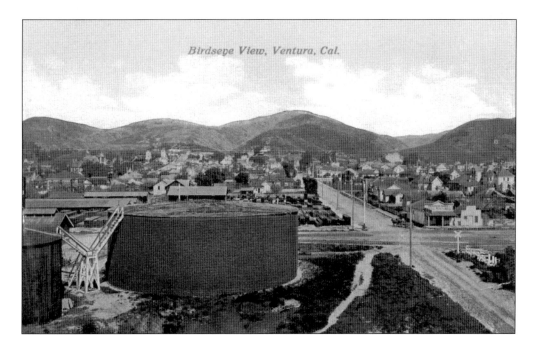

Birdseye View, Ventura, Cal.

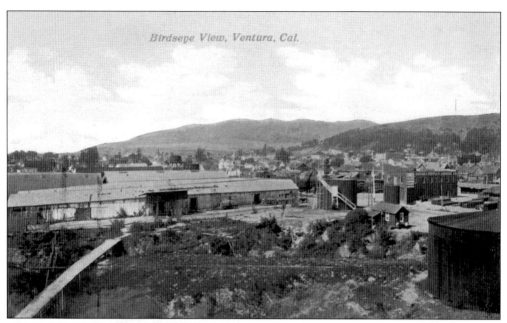

This image is taken closer to the foot of the Ventura Wharf. The large, round tanks held crude oil.

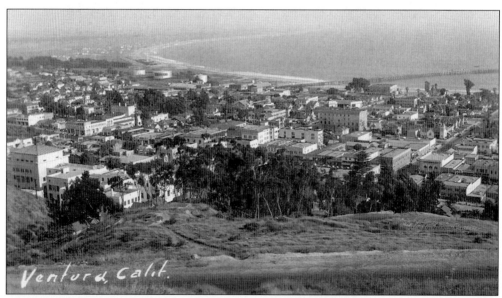

Ventura, Calif.

This photograph postcard shows a bird's-eye view of Ventura taken from Grant Park. The bathhouse is visible at the shore, as are the crude-oil tanks in the center of the card.

Three

THE MANY FACES OF
MAIN STREET

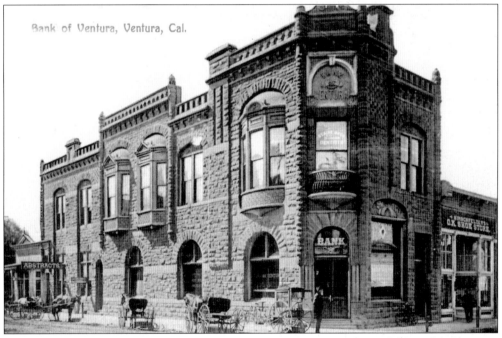

On January 1, 1892, the *Ventura Signal* reported that the "new building of the Bank of Ventura is one of the handsomest structures in the county. It is on the corner of Oak and Main Streets and is two full stories in height and covers twenty-five feet and ten inches in width by 100 feet in length. The front and side are of hewn brownstone, taken from the quarry several miles from town, and over the windows are ornamental zinc cornice pieces. Over the main entrance is a carved stone bearing the words "Bank of Ventura 1891." The bank became the National Bank of Ventura, then the Bank of Italy, and then Bank of America. The building was demolished in September 1923, and a new building by Bank of Italy built in 1924. Hirschfelder's OK Shoe Store is to the right of the bank.

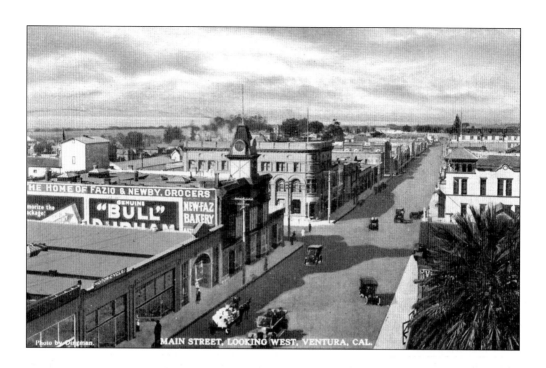

The above image was taken probably from the rooftop of the Hotel Rose on Chestnut and Main Streets. The "Bull Durham" advertising sign on the Fazio and Newby Grocery store, long ago covered by adjoining buildings, was uncovered in the early 1990s after a fire destroyed an adjacent business. After reconstruction, it is once again hidden from view. The clock tower of the IOOF, once a downtown landmark, no longer exists. The card below depicts many businesses, including Hotel Baldwin in the foreground.

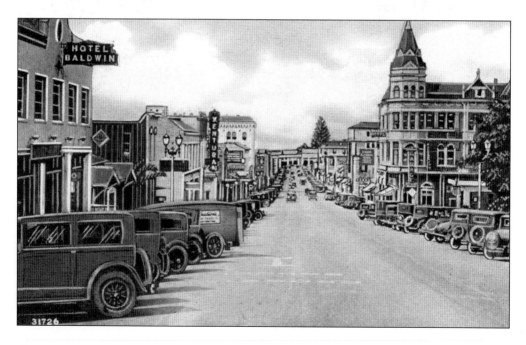

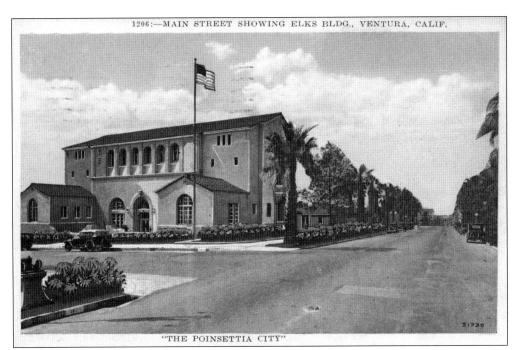

This is the Elks Lodge on Main Street in the 1920s. Ventura was originally known as the "Palm City," but was renamed the "Poinsettia City" late in that same decade. During a Thanksgiving parade, merchants displayed containers of poinsettias in windows, and residents were encouraged to buy them and plant them. The poinsettias thrived and still grace yards in older neighborhoods. The Elks Lodge was recently sold and is being restored.

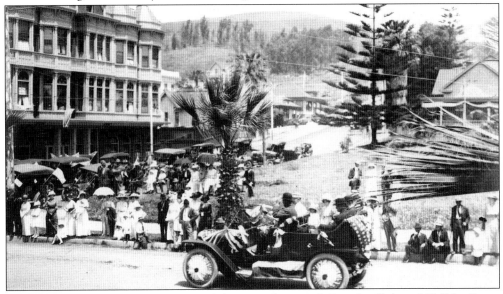

Today's Ventura County Fair Parade and the City of Ventura's Fourth of July and Holiday Street Fairs draw thousands of visitors each year to the historic downtown. This photograph shows the Fourth of July parade c. 1913. Ed Mercer, owner and operator of Mercers Garage and the man driving the car, was the official chauffeur for local dignitaries and was made an honorary Ventura police officer by the department. (Courtesy Dena Mercer.)

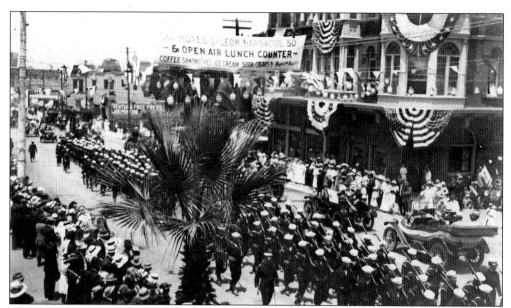

This photograph, taken *c.* 1913, shows a military regiment on parade in front of Hotel DeLeon on Main Street. Parades were organized for just about anything. The coming of President McKinley kicked off a town beautification and parade. When Thomas Bard was elected Senator, the town celebrated with a parade. Today's local parades also include one for St. Patrick's Day. (Courtesy Dena Mercer.)

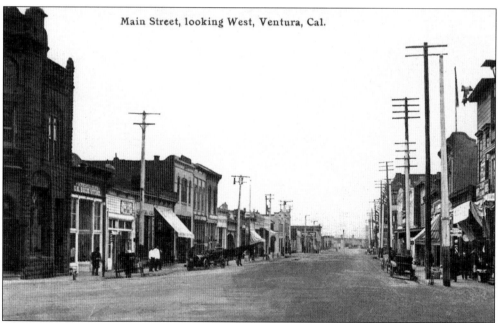

The building to the left is a portion of the elaborate Bank of Ventura. It's interesting to note that horses and buggies shared the road with motor vehicles. Today's Main Street still remains quaint. The *Ventura Signal* reported a fatal accident on November 2, 1872, "Yesterday a four-horse team ran away on Main street and in their frenzy ran over and instantly killed an old man, a native Californian, whose name we did not learn."

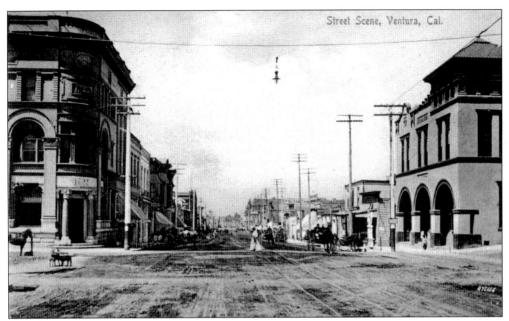

This card shows the intersection of Main and California Streets. Constructed in 1899, the building on the left is the First National Bank of Ventura. The building at right is the city hall and the library, demolished when Hotel Ventura was constructed in the mid-1920s. The Angel of Temperance statue stands on the sidewalk outside city hall; its fate is unknown. Trolley tracks are visible down the center of Main Street.

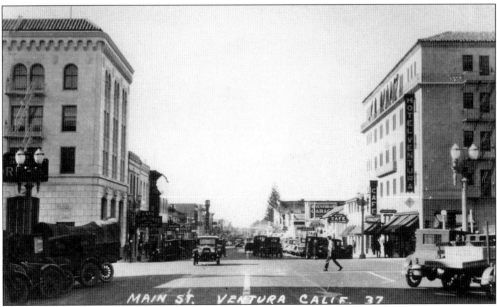

This photograph postcard shows the same intersection as above. The building on the left was built in 1926 as the Bank of America. It still stands today and is locally known as the Erle Stanley Gardner building. Gardner had an office on the third floor, and it was in this building that the character of Perry Mason was born. Across the street is the Hotel Ventura, built in 1926, and now a residential facility.

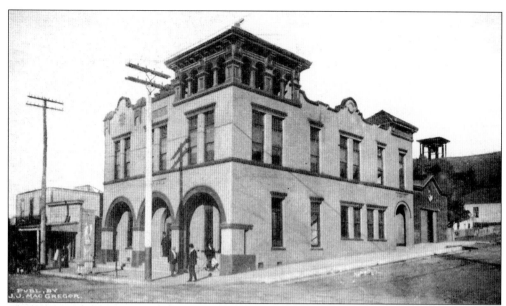

This building housed both city hall and the Ventura City Library (1903–1925), but proved to be less than desirable for a library. It was described as "two upstairs rooms in a poor location . . . each 24x48. Front room used as a reading and study room combined. Rear room contains Librarian's desk and aisles of books. There are no children's rooms . . . nor any way of fixing present quarters for same."

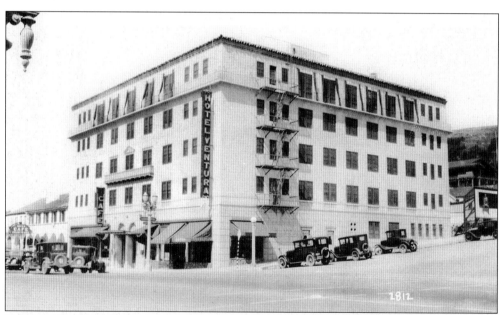

Hotel Ventura, the "largest and most modern hotel between Los Angeles and Santa Barbara," was built *c.* 1926 on the site of the old city hall/library. It is neo-Spanish in architecture and was built by Mr. Gus Berg, owner of the De Riviers Hotel in Santa Barbara. Silent-movie star Theda Bara is said to have spent the night there with her husband and while enjoying breakfast she proclaimed Ventura a "pretty nice place."

The El Jardin, Southern California's first outdoor shopping mall, was built in 1925. The July 1928 issue of *Pacific Coast Architect Magazine* provided this description: "Entering the commercial court, the shopper feels that he is in another world. Here is a fountain, trees, flowering shrubs, and pleasant nooks in which its rests . . . where shopping becomes a pleasure." The area still operates as a mini-mall today and is located in the 400 block of Main Street.

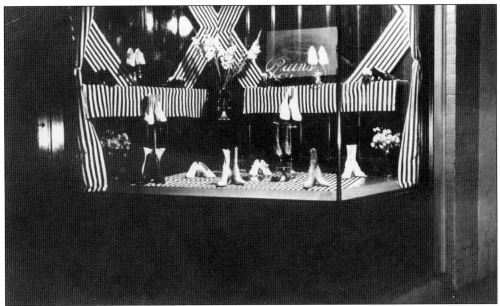

This postcard depicts the opening day of Rains Shoe Company in 1910. A business staple of the downtown for 95 years, it closed in 2005. Emanuel Hirschfelder's OK Shoe Store was in this shop before Rains. Some say the ghost of Mr. Hirschfelder can be detected through the smell of cigar smoke in the "slipper room" at the back of the building.

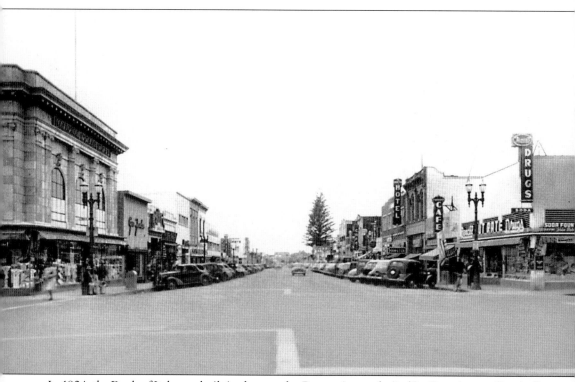

In 1924, the Bank of Italy was built in the popular Beaux-Arts style (Italian Renaissance Revival) and replaced the earlier Bank of Ventura. Marble bas-relief was imported from Italy. The building has seen many renovations over the years. The 2001 movie *Swordfish*, starring John Travolta and Halle Barry, was filmed in and around downtown Ventura and included a Hummer driving through the window of this building. Rexall Drugs across the street is now Bank of Books. (Courtesy John Burgman.)

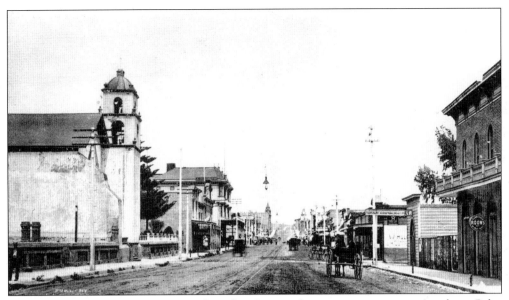

"Runaways are getting too common for safety. Last week a grey team came tearing down Palm and up Meta Street at a fearful speed, but was finally halted without serious damage. Sunday, Frank Bisbey was thrown from a double carriage and slightly injured. The horses ran down Main Street but were overtaken and lassoed by a daring knight of the riata. An ox team came dashing past at a fearful gait, its driver prodding them at every jump with a pitchfork and yelling whoa!" reported the *Ventura Signal* on July 6, 1872.

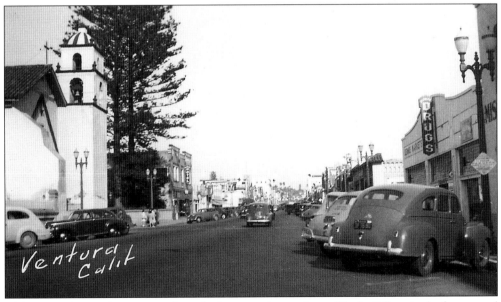

This *c.* 1930s image shows approximately the same view as above. The buildings in the foreground on the right no longer exist; the land is now Mission Plaza Park. An interesting feature about the Norfolk pine trees is they can be used to date images of the mission. Since the date of planting is know, it's easy to date images based upon the growth of the trees.

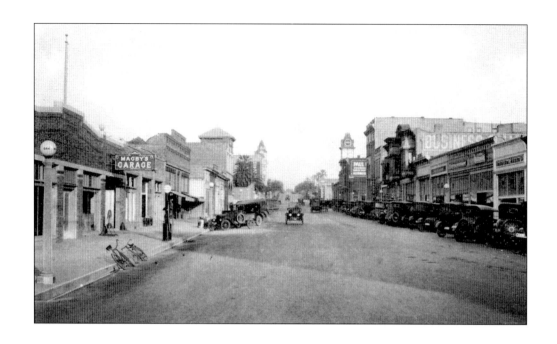

These two images show Main Street between Oak and California Streets, looking east toward California Street. The IOOF clock tower and Hotel DeLeon are visible above, while in the card below, both landmarks are gone. Magby's garage was located at 626 Main Street.

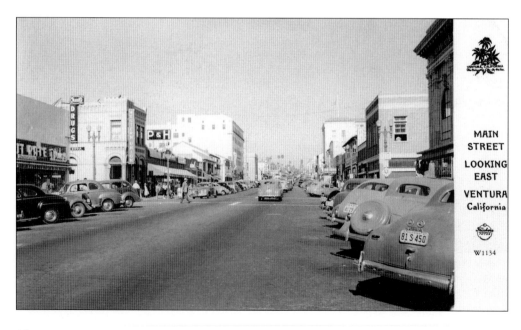

Four

AND JUSTICE FOR ALL

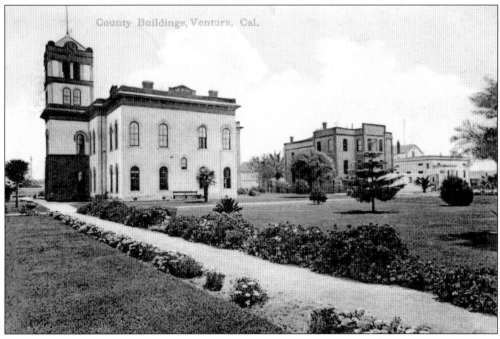

After Ventura County was formed in 1873, the first county offices operated out of Spears Saloon on Main and Palm Streets (now Capriccio's). In 1875, a new county courthouse was built on Santa Clara Street between Figueroa and Colombo, followed by a county hospital and jail. It became the Mae Henning School before being demolished. (Courtesy John Burgman.)

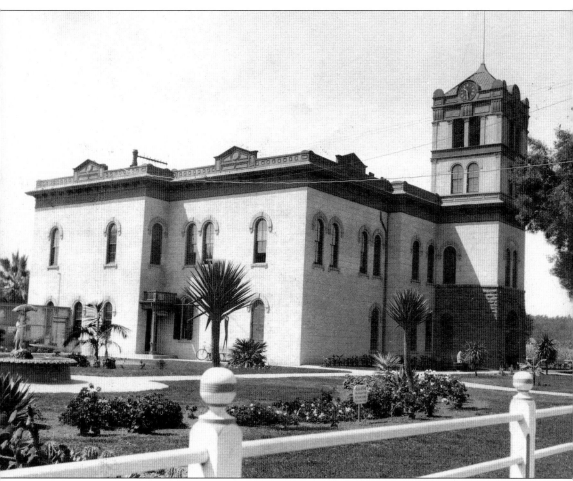

The murder trial of Vicente Garcia in 1881 brought curious onlookers to the county courthouse. Garcia was found guilty of murdering Estanislao, a Chumash Indian bridle maker, and sentenced to hang. Gallows were constructed on the grounds but the governor commuted his sentence to life imprisonment at San Quentin. (He may have been innocent.) The fountain pictured at left eventually made its way to the Olivas Adobe, where it stood for many years.

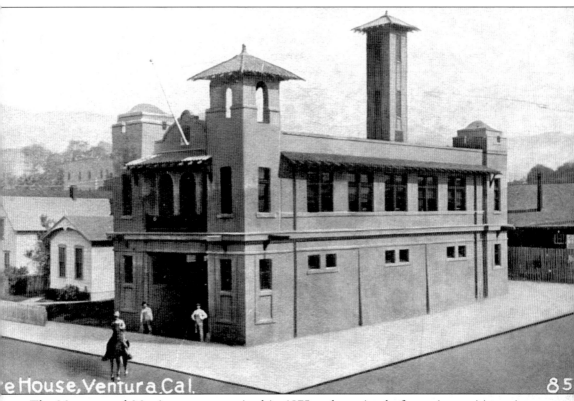

The Monumental Monitors was organized in 1875 and consisted of prominent citizens in town. They were issued fancy uniforms and proudly marched in all town parades. In 1878, they became the Monumental Hook and Ladder Company. This is the old firehouse on the corner of California and Santa Clara Streets that was built in 1908. It was designed to accommodate a horse-drawn fire truck. In 1924, the Ventura Police Department moved to the second floor. The firehouse was demolished in 1941. (Courtesy Suzanne Lawrence.)

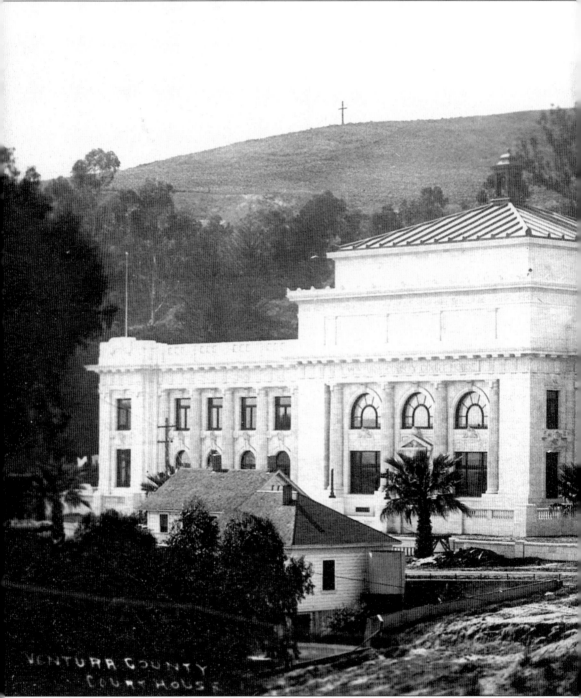

VENTURA COUNTY
COURT HOUSE

The historic Ventura County Courthouse (now Ventura City Hall) is located at 501 Poli Street at the top of California Street. Built in the Beaux-Arts style, the building features 100-foot wings, Doric columns, Roman-arched windows, a pedimented entry, copper dome, and cupola. Busts of friars' heads adorn the main courthouse building and are a reminder of Ventura's humble beginnings as a small mission town in 1782. The cost of construction in 1912 was $250,000.

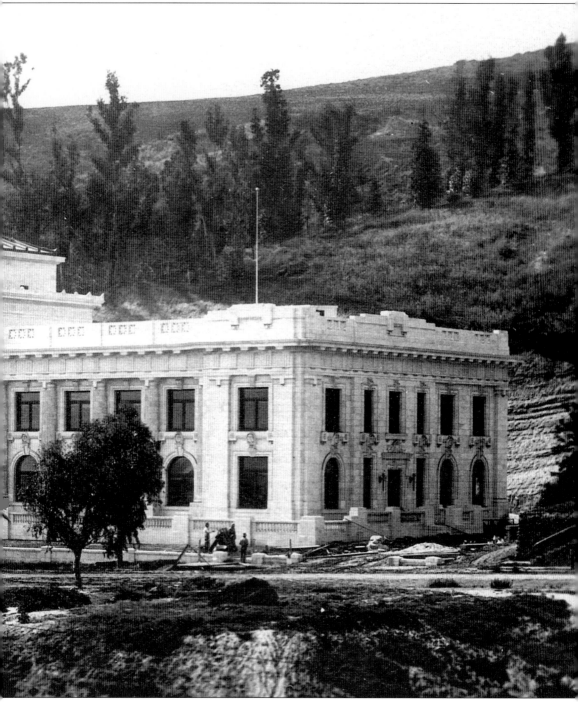

The population of the county at that time was 20,000 with 5,000 people living in Ventura, the county seat. From 1913 until January 1, 1969, it was the Ventura County Courthouse. The county declared it seismically unsound and was poised to demolish it when the City of Ventura came forward and saved it. (Courtesy Jeff Maulhardt.)

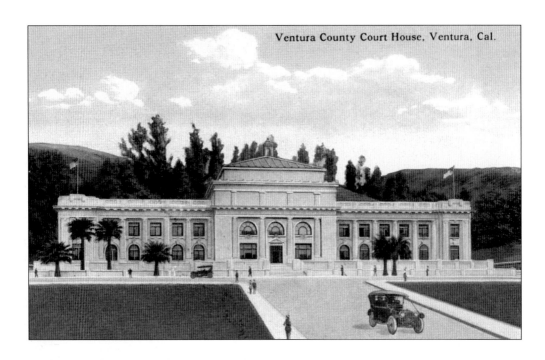

Ventura County Court House, Ventura, Cal.

The exterior tiles are terra cotta (baked clay), handmade of a sand and clay mixture that is beaten, kneaded, placed in molds, glazed, and then fired at very high temperatures. The original plant that produced the tiles is still in operation today—Gladding McBean. The City of Ventura purchased the courthouse from the County of Ventura in 1971 for $145,000. Over the course of three years, and spending a total of $2.7 million dollars for rehabilitation, the building reopened on January 8, 1974, as Ventura City Hall. It is a registered historical landmark.

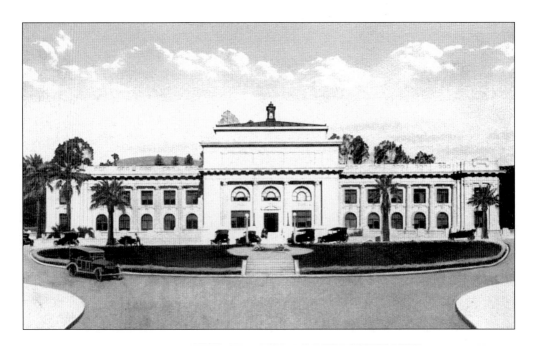

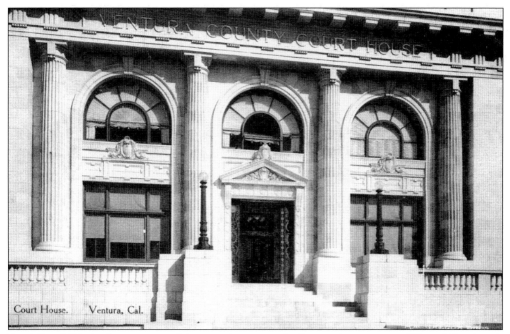

Court House. Ventura, Cal.

Partially visible in the entrance of the courthouse are the bronzed entry gates. When fully closed, the initials SBCH are seen, which originally stood for San Buenaventura Court House and now for San Buenaventura City Hall. The highly decorated gates contain bouquets of lima beans, Ventura County's cash crop which, in essence, paid for this glorious building. The building is open to the public during weekdays and during weekend tours offered by the Department of Community Services. (Courtesy Shawna Atchison.)

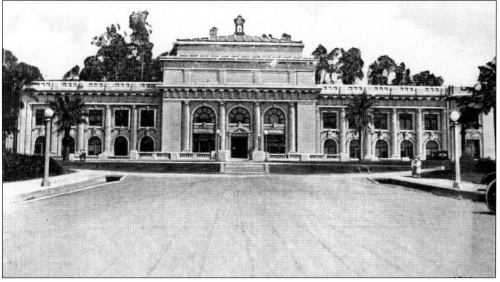

The elegant courthouse was designed by noted architect Albert C. Martin, who also designed Grauman's (now Mann's) Chinese Theater in Hollywood. In 1913, he designed the Chapel of Mary Magdalen in nearby Camarillo, and designed the facade of the Bella Maggiore Inn on California Street in 1926. His grandson David C. Martin is currently designing the expansion of the Ventura County Museum of History and Art.

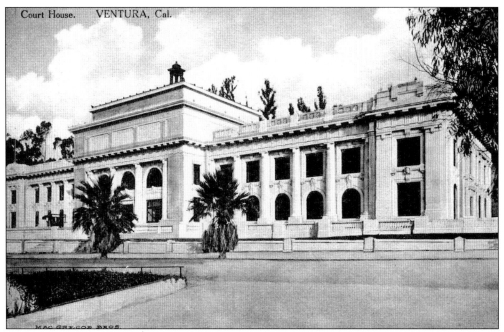

Court House. VENTURA, Cal.

The interior of the building is lined in imported Carrara marble from the same Northern Italy quarry used by Michelangelo for his statue *David*. Coffered ceilings, ornate plaster friezes, and original chandeliers are found throughout the building. The beautiful stained glass domes in the (current) city council chambers were a gift from the architect. The dome centers depict the three icons of justice—the sword, the scale, and the law book. (Courtesy Shawna Atchison.)

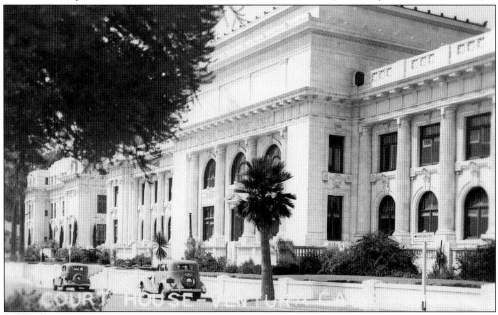

Construction of the annex (1927–1932) cost $450,000 and is visible at the left of the card. It originally housed the sheriff's office, with a women's jail on the third floor and a five-story men's jail in back. In 1984, the city purchased the annex for $700,000, fully restored it, and reopened on April 23, 1988. Interestingly enough, the Friar's Heads do not adorn the annex.

This 1920s photograph postcard provides the sweeping view down California Street toward the ocean and pier. The large building just beyond the palm tree on the left is the Union National Bank of Ventura, which featured the county's first drive-through teller in the 1940s. Note that the concrete statue of Father Serra has not been done yet. (Courtesy John Burgman.)

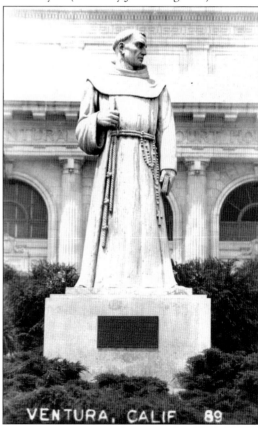

In 1936, John Palo Kangas created the Federal Works Project Administration concrete statue of Father Serra. It stood below the courthouse for 50 years, but was deteriorating badly due to a combination of sea air and a 1970s Halloween prank. Someone painted the statue green and to remove the paint, the city had to sandblast it, allowing moisture to seep in creating cracks. In the mid-1980s, the council voted to undertake a fund-raising campaign to replace the statue.

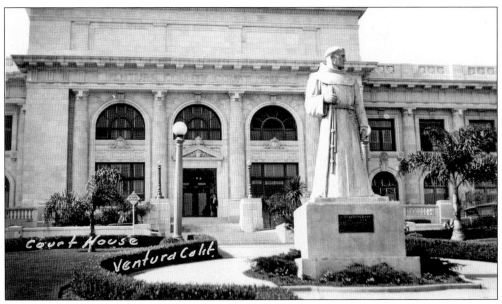

More than $100,000 was raised to replace the statue. The Channel Islands Master Carvers spent nearly a year carving a replica in basswood then the concrete statue was removed from its base by an OST crane. College of the Desert in Palm Desert poured the bronze statue from a mold of the wooden replica. Today there are three statues: the bronze one, the wooden one in city hall, and the still-encased original one stored away. (Courtesy Shawna Atchison.)

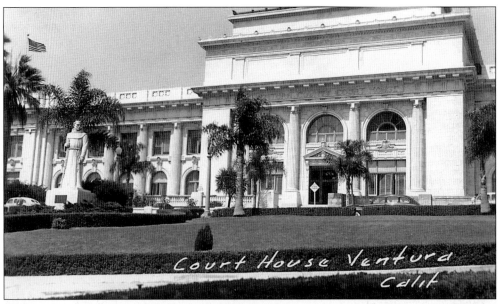

Since opening its doors as Ventura City Hall, Hollywood has come calling. From television commercials to pilots to feature length films, this historic landmark is always ready for its close-up. Jack Nicholson filmed portions of *The Two Jakes* in the council chambers; a television version of *Dangerous Minds* was filmed in another old courtroom, and *Swordfish* took over downtown.

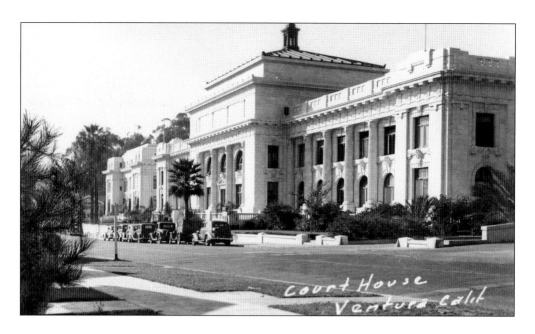

As a county courthouse, many trials took place within its marbled walls, none more bizarre than that of the 1959 Ma Duncan murder trial. Indicted by the grand jury for the murder of her pregnant daughter-in-law, the trial captured worldwide attention and plunged Ventura into the spotlight. Hundreds of people and reporters arrived before daylight vying for a chance to get into the building. After her conviction, Duncan was the last female executed by the State of California in 1962. In the late 1960s, another infamous murderer visited Ventura—Charles Manson. He was picked up and held overnight on a minor violation; then released. Soon the mug shot taken by the Ventura County Sheriff's Department appeared in AP news wires following his masterminding of the Tate-La Bianca Murders. (Below courtesy Cynthia Thompson.)

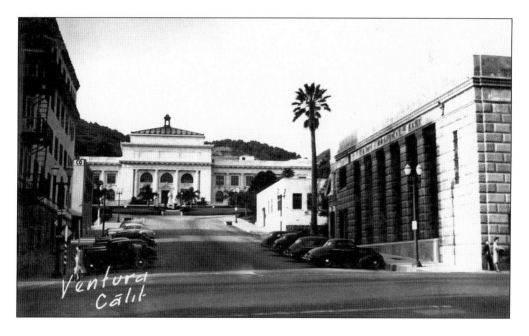

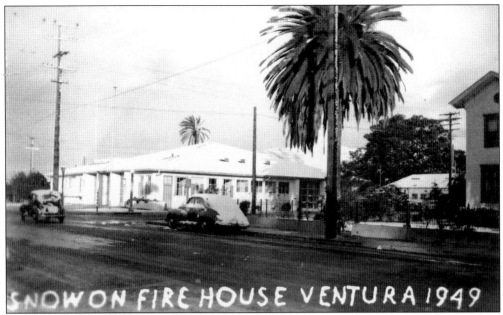

Rarer than hen's teeth is snow in Ventura, but in January 1949 the white stuff settled all over town for a full three days. From the shoreline to the pier to the firehouse on Santa Clara, it was the talk of the town—and still is. It hasn't gotten cold enough since then for the white stuff to return. (Courtesy John Burgman.)

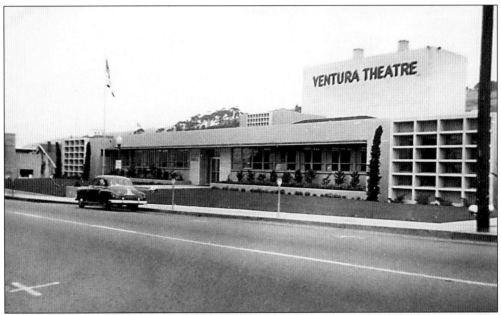

From Spears Saloon to the corner of California and Main to the Foster Library, city hall finally found a fairly nice-sized building on Santa Clara. This was originally the site of the First Congressional Church of Ventura. The opulent Ventura Theater (in the background) opened its doors in the late 1920s and is currently used for music concerts. It should be restored to its once magnificent glory. (Courtesy John Burgman.)

Five

PIER, PARK, AND PLUNGE

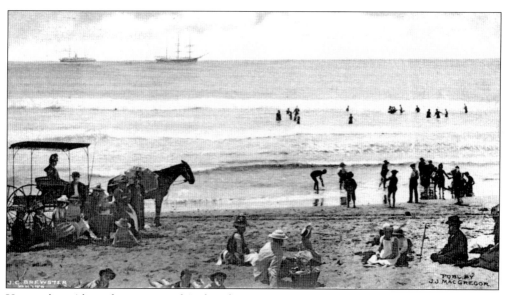

Ventura's residents have enjoyed its beaches since time immemorial. This group of happy beachgoers frolics in the surf and on the sand around 1893. The steamships off the coast were once a very common sight as they made their way back and forth from Southern California to San Francisco. The town photographer, John C. Brewster, captured this shot.

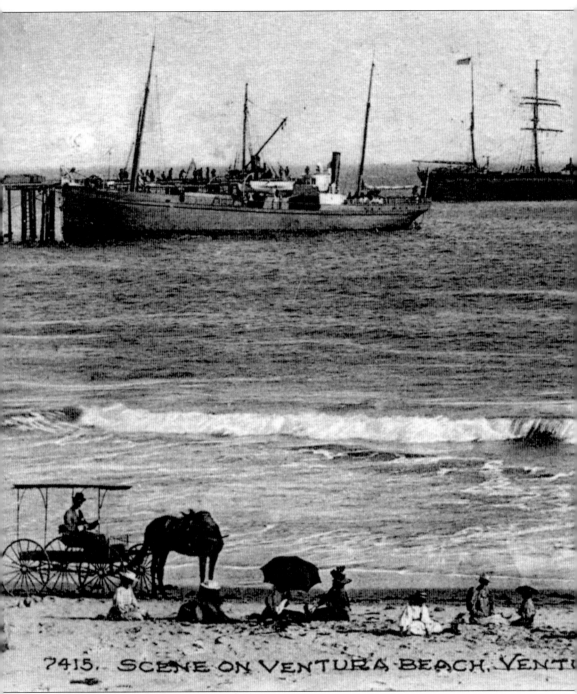

7415. SCENE ON VENTURA BEACH. VENT[U]

"The following telegram is posted on the bulletin board at the Santa Clara House: 'J. Wolfson, San Buenaventura: Wharf requisition will be shipped as soon as vessel ready. Heyneman & Co.' That looks like San Buenaventura is to have a wharf, but people here have been humbugged in that matter so often that seeing alone will be believing," reported the *Ventura Signal* on February 3, 1872. The wharf finally became a reality and was the busiest wharf between San Pedro and San Francisco. However, the wharf was not without mishaps. The *Coos Bay* smashed through

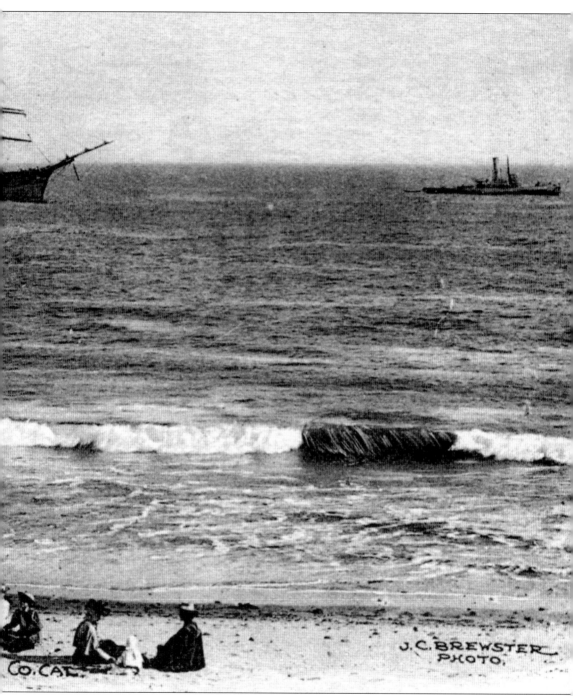

the middle of it on December 19, 1914. All her cargo of Christmas merchandise was lost, and the wharf was shut down. It reopened in 1917. The *Coos Bay* was not the only ship to meet with disaster. There were approximately 12 other ships that ran into or aground near the wharf. In fact, several city streets are named for ships, including Ann Street, Kalorama Street, and Crimea Street. (Courtesy Ventura County Museum of History and Art.)

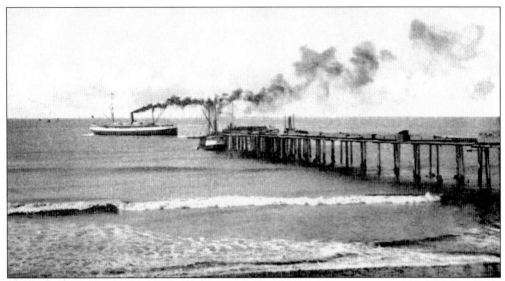

Passengers in 1905 wait at the end of the wharf to board an excursion steamer to the islands. Before the wharf was built in 1872, arrival at Ventura was an adventure. Edith Hobson in *Reminiscences of Old Ventura (1912)* recalled arriving to Ventura as a child: "Slowly the little old steamer came to anchor and prepared to unload her impatient passengers, the said unloading being accomplished by means of a pulley and legless chair suspended by ropes, in which we were lowered to the lighters [boats] below, which was rowed by sailors who carried us on their backs through the surf."

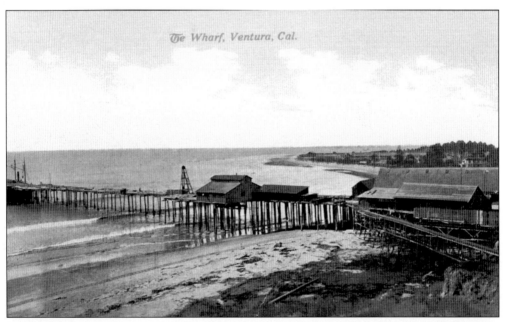

Narrow tracks were laid on the deck for horse-drawn cars to carry beans, grain, lumber, fruit, and produce on and off the wharf. Over the years, the wharf was rebuilt several times due to age and storm damage. It was also the longest wooden wharf in California until a storm knocked out 425 feet in the early 1990s. (Courtesy Cynthia Thompson.)

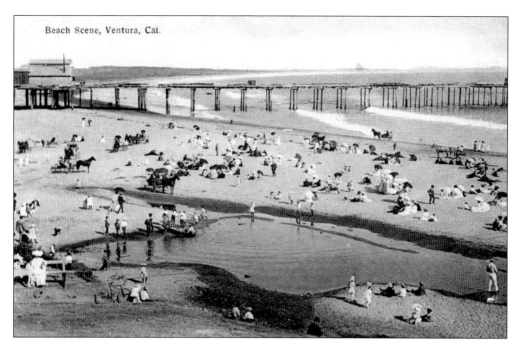

Beach Scene, Ventura, Cal.

A popular destination spot for residents and visitors, these cards depict beach scenes from the early 1900s and 1920s. Residents and tourists still flock to the beach, although some visitors are disappointed when a period known as June gloom darkens the Southern California coast with fog, clouds, and haze. So much for "sunny" Southern California. (Below courtesy John Burgman.)

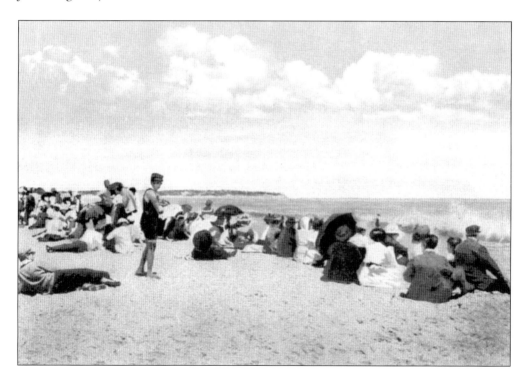

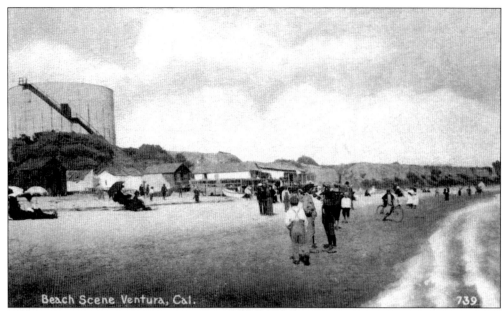

This c. 1920s postcard shows the beach, bathing "houses," bluffs, and large tanks used to store crude oil. The West Coast's first oil tanker, the *W. L. Hardison*, rammed the wharf in 1899, and burned. Initially a Chinese cook was blamed for the fire, but it was finally discovered that a shipmate had lowered a kerosene lantern into the holds and dropped it, igniting the fire.

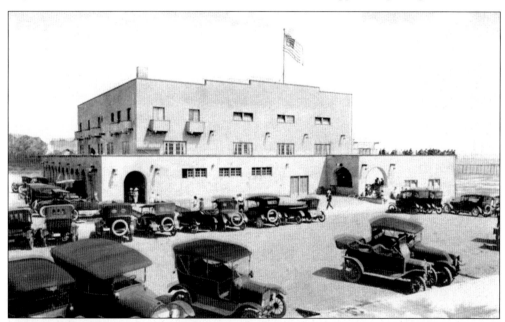

As early as 1872, locals wanted a bathhouse. "To Miss Maggie Hailey and Miss Mattie Edington the people of San Buenaventura will be indebted for a seaside bathing establishment, a long needed consideration," reported the *Ventura Signal* on July 6, 1872. "On Monday they collected over a hundred dollars in cash, and secured the promise of labor and material for erecting and furnishing a commodious and elegant bath house. It will add much to the attractions of the place and the spirited young ladies are entitled to the thanks of the community."

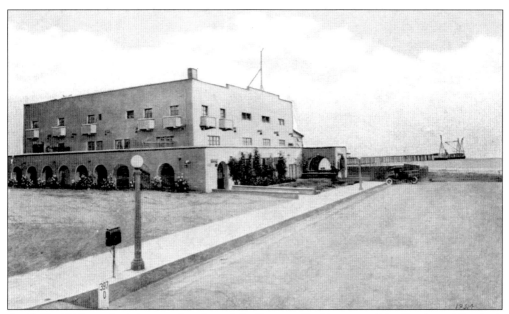

April 22, 1918, marked the opening day of the Ventura Bathhouse and Auditorium. The day's festivities kicked off with Norma Gould and her dancers performing classic, interpretative, and national dances. Even today, longtime Ventura residents fondly remember the days of dance lessons, skating parties, and lots of fun at the old Ventura Bathhouse. (Courtesy Cynthia Thompson.)

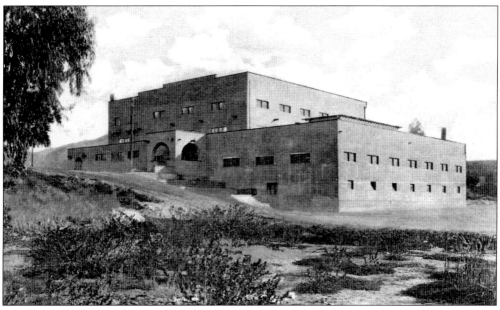

The front of the bathhouse and parking lot were located on the east side of California Street facing west with the wharf in the back. A swimming pool was on the main floor along with showers and dressing rooms. The second floor held a dance floor and large stage, and caretakers lived in an apartment at the top of the building. (Courtesy John Burgman.)

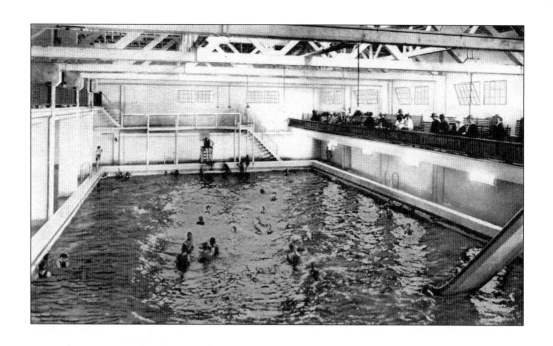

In the early days of the bathhouse, fresh ocean water was used to fill the pool, but eventually the pool was covered over and a skating rink installed. The City of Ventura purchased the building in the 1930s as a possible convention center and recreational building. However, the old bathhouse was eventually condemned and torn down around 1957. It is the present site of the parking structure on Harbor Boulevard at the end of California Street.

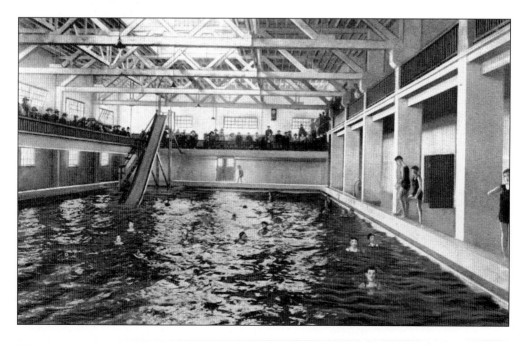

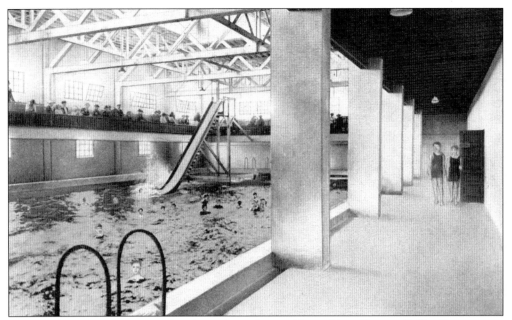

It seems that crime knows no decades or bounds as evidenced in a Ventura Police Department report of November 16, 1937: "Lost or Stolen Property. The victim came in the office and reported the theft of a yellow oil skin coat and hat from his car while parked near the skating rink on South California Street."

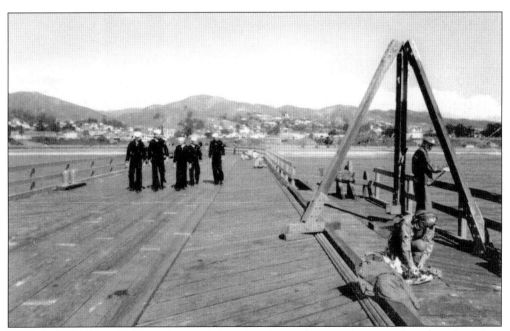

After its use as a commercial wharf faded in the 1930s, the Ventura Pier enjoyed a rebirth as a recreational destination for fishing. A walk to the end of the pier remained a popular pastime, as these sailors from the nearby Port Hueneme Naval Base found out in the 1950s. Today the pier houses a snack shop and restaurant and remains a popular tourist destination.

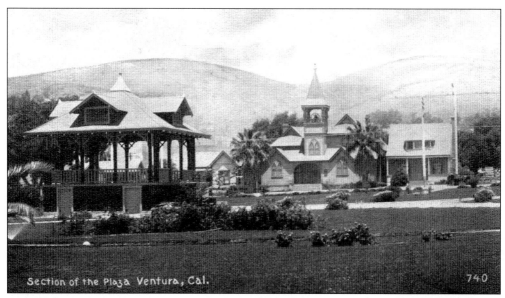

The official town map of 1869 shows Plaza Park already in place. Bounded by Santa Clara Street, Chestnut Street, Fir Street, and Thompson Boulevard (then called Meta Street), the park has been a mainstay and attraction for families ever since. This image of Plaza Park *c.* 1910 shows the old Congressional Church on Santa Clara Street.

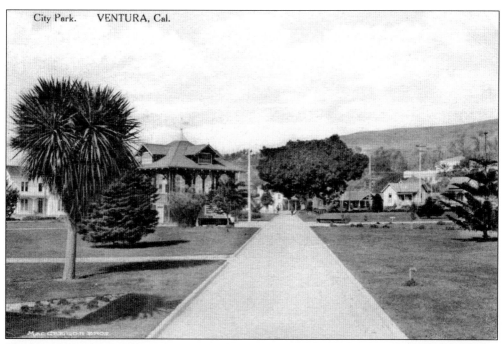

The large Moreton Bay Fig Tree (center of card), native to Australia, was planted in 1874. The gazebo stood in the park until the 1930s, and was the backdrop for political rallies and band concerts. In 1892, the Veterans of the Grand Army of the Republic gathered in the park to commemorate the 27th anniversary of the end of the Civil War.

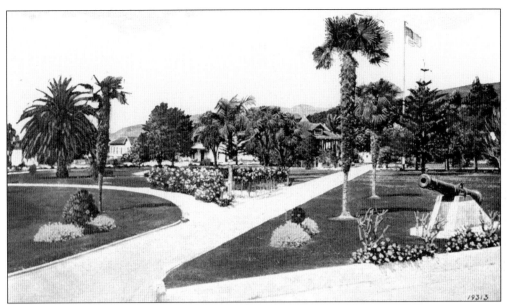

Plaza Park became overgrown with Cypress trees. After the trees were cut down, a dynamite "expert" was hired to remove the stumps. To the horror of the surrounding neighbors, he blasted wood in all directions. The "expert" was promptly replaced. It was then decided that planting potatoes would neutralize the soil. The cannon dates to the 1700s and is named San Buenaventura. It guarded the city of Manila in 1898, and was brought to Ventura and placed in the park in 1903.

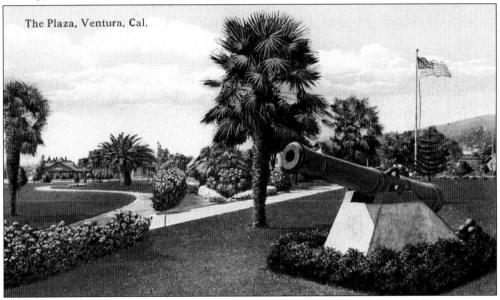

The Plaza, Ventura, Cal.

On April 27, 1906, the *Ventura Weekly Democrat* wrote the following: "Captain Blake has decided on a crop of fragrant potato blossoms, which will be doubly remunerative, in that when the bouquet season expires the 'spuds' themselves will come in handy for winter provender. There are several tons of wire grass roots to be reckoned with before the seed could be planted successfully, but a little thing like that will not daunt the Captain, for other subterfuge should fail, he would load up that old cannon with potatoes and shoot them into the soil."

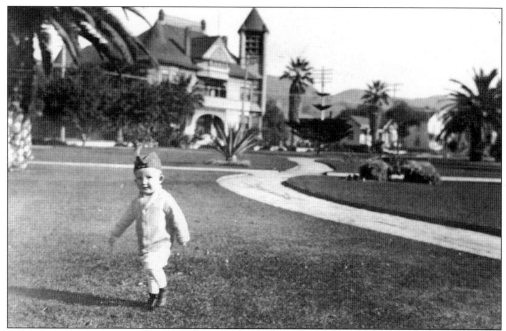

This *c.* 1913 photograph shows an 18-month-old Dean Mercer playing in Plaza Park. Rising in the background is Plaza Grammar School, once located on Santa Clara Street where the post office stands today. (Courtesy Dena Mercer.)

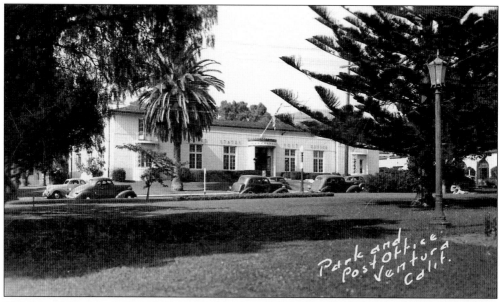

This late 1930s postcard depicts nearly the same view as the above photograph, but now the "new" post office on Santa Clara Street has replaced Plaza School. The town's first post office was located at 377 East Main Street. Ventura is actually credited with the development of letter carriers. The town's first postmaster in 1861, V. A. Simpson, carried letters for delivery in his hat!

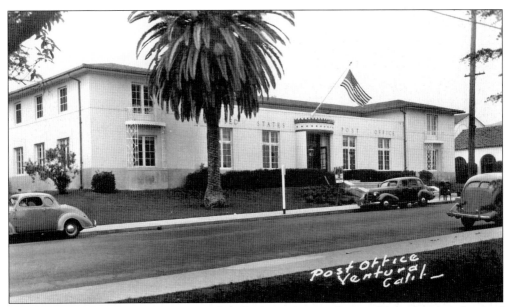

The post office on Santa Clara Street is officially the city's "main" post office and was modernized in the 1960s. Inside the post office are beautiful murals painted as a part of the federal Work Projects Administration and well worth a visit to this old post office. (Courtesy John Burgman.)

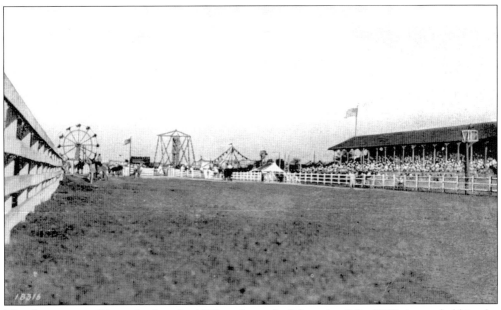

The first county fair took place in 1874 at the end of the wharf. In 1877, it was held in the Pierpont Bay area and lasted four days. Events included horseracing, a display of county products, and a grand ball each night at Spears Saloon on Main Street. Then in 1891, it moved to Port Hueneme. Mrs. and Mrs. E. P. Foster donated the ocean front land near Figueroa Street that is now the site of Seaside Park and the annual Ventura County Fair. Since about 1914, the county fair has been held in Ventura. (Courtesy Shawna Atchison.)

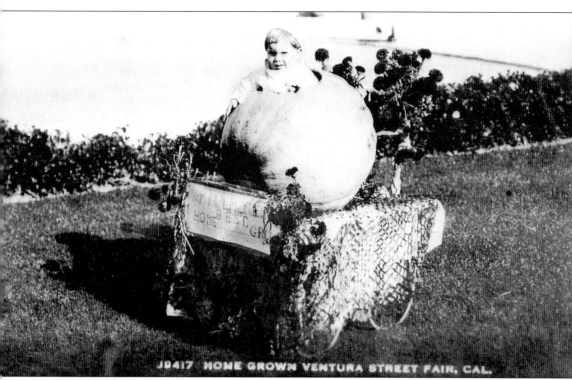

J9417 HOME GROWN VENTURA STREET FAIR, CAL.

A cute little lad sits inside a very large pumpkin. The cart sign reads, "Fillmore's Best Home Grown" and was either a display at the county fair or a float in one of the many parades held in Ventura. The Ventura County Fair attracts thousands of visitors yearly to Ventura. In the early days, the fair was held in August, but switched to October and for decades the first day of the fair (Wednesday) was celebrated with a parade down Main Street. It was also a school holiday, but that tradition ended when the parade was switched to Saturday. The fair now takes place again in August.

Six

Seeds, Books, and Rooms to Let

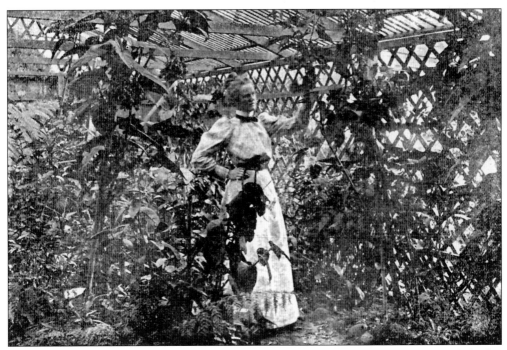

Theodosia Burr Shepherd gained worldwide fame when she began offering her seeds, bulbs, and roots for sale through mail order. Her two-acre gardens were located on Main Street between Poli and Chestnut Streets, and she became known as the Flower Wizard of California. Visitors from as far away as Los Angeles would take the train just to tour her gardens. (Courtesy UC Davis.)

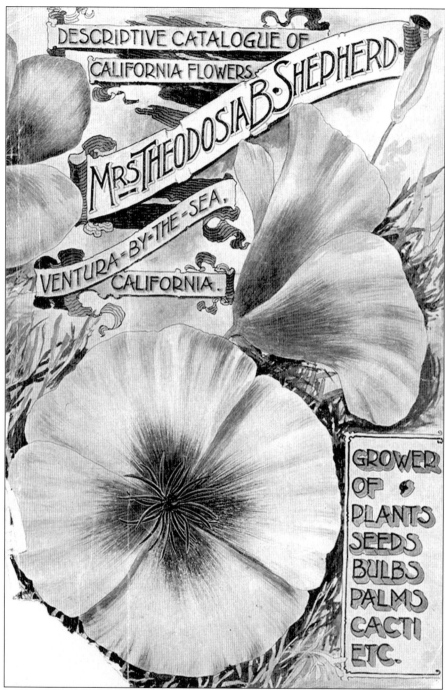

This is the cover of one of Theodosia's rare seed catalogs. She is credited with our "Ventura-by-the-Sea" nickname. It seems a customer from England worried that her seed order would be lost in the mail and addressed the envelope to "Ventura–by-the-Sea, as it is the first place glimpsed by passengers coming to California on the Southern Pacific." In the early days, with no piped water available, Theodosia actually converted an old upright piano into a temporary greenhouse! The seedlings survived and flourished under her expert guidance. (Courtesy UC Davis.)

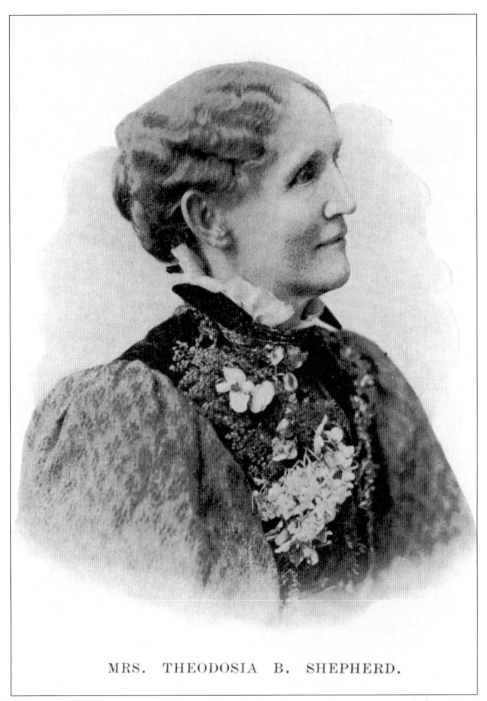

MRS. THEODOSIA B. SHEPHERD.

As requests for her seeds and plants grew, Theodosia took to renting vacant parcels from Ventura residents. In 1886, she displayed her flowers in the Floral Fair at Hazard's Pavilion in Los Angeles and "put San Buenaventura on the map." Theodosia's business continued to flourish and, while she had a wonderful green thumb, she did not have a great deal of business sense. Orders often exceeded her supply. Theodosia died on September 6, 1906, and, ultimately, so did her once-beautiful gardens. (Courtesy UC Davis.)

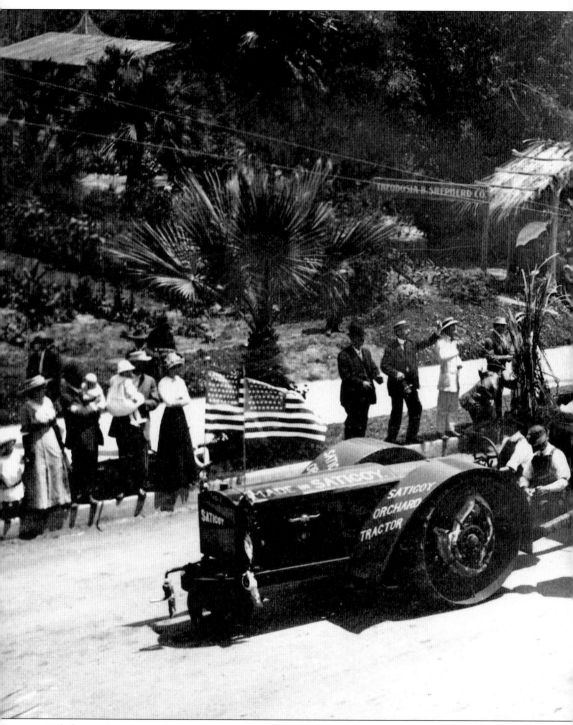

While much information is known about Theodosia and her gardens, very few photographs actually exist. What is noteworthy in this rare parade scene is not the Saticoy tractor pulling the float with children dressed as Indians, but the view of Theodosia's gardens in the background! Plainly seen to the right above the sidewalk are her neat rows of calla lilies. Her little thatched

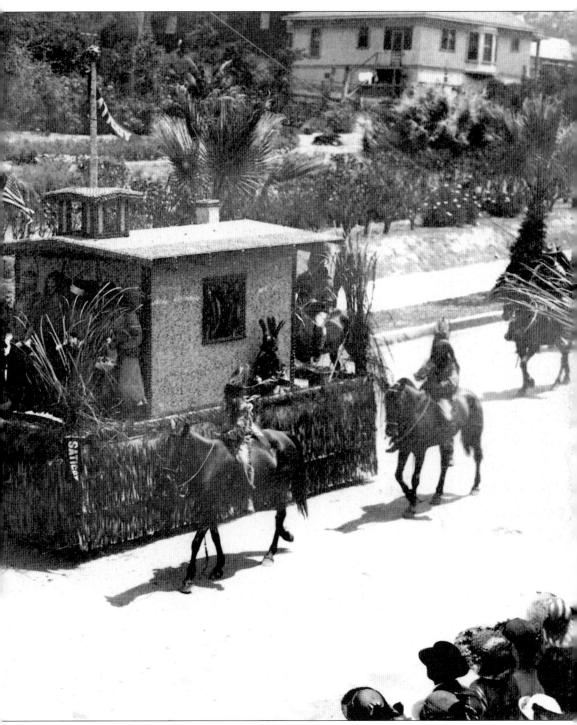

hut is in the center and the Theodosia B. Shepherd Company sign is next to the hut. Today nothing but a few plants and trees remain to remind us of the once flourishing gardens of this Flower Wizard of California. (Courtesy Dena Mercer.)

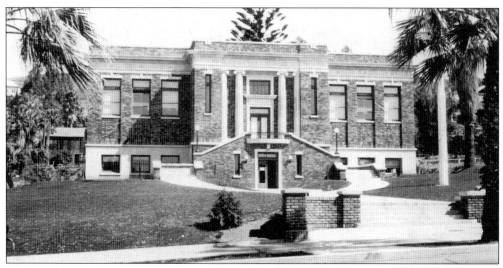

From its earliest days in the 1870s, when "to get a book they should have to call Mr. J. R. Newby from some fascinating game he was playing with his cronies," to the small cramped quarters above city hall on Main and California Streets, Ventura finally received a brand-new library in 1921. A gift to the city from Mr. and Mrs. Eugene P. Foster, this beautiful brick building housed the library and city hall, and was built where Theodosia's gardens once grew.

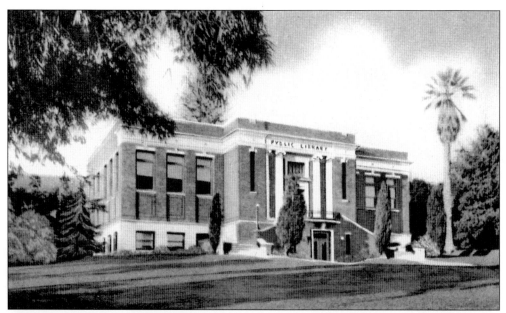

"Not only is the new building fine, but the garden is beautiful. From the desk you can look through the French windows to a paradise of green in the middle of which is a fountain and two pools where children sail their toy boats and play. The stones of this fountain Mr. Foster laid and plastered with his own hands. He wisely chose the site of the old Shepherd Gardens, famous among all lovers of petunias and cactus." (Sol Sheridan, *History of Ventura County, 1926.*)

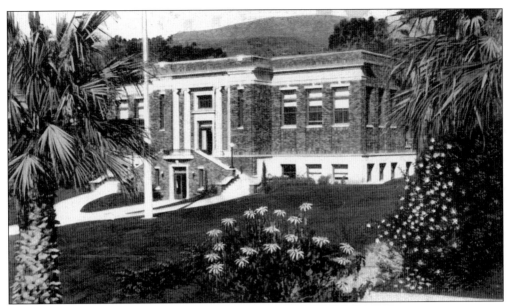

In 1959, the beautiful brick facade of the library was lost to public view when the large concrete structure was added in front. The sweeping lawn was covered and the fountains torn out. Entering the library from the back parking lot, one can still glimpse the original brick building. Today the once beautiful home of Mr. and Mrs. E. P. Foster on Ventura Avenue is boarded up and deteriorating. It is hoped that someone will save this house before it too is lost forever. (Courtesy Cynthia Thompson.)

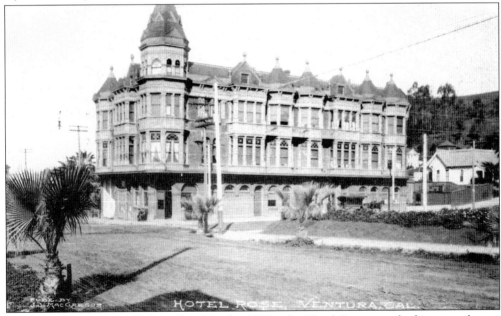

Built after the coming of the railroad in the 1880s, the Hotel Rose was the largest and most elaborate hotel on the West Coast. With its ornate facade and fancy furnishings, it played host to many visiting dignitaries. Located on the corner of Chestnut and Main Streets, it was across the street from Theodosia's gardens. There was also a bit of rivalry between the Rose and the Anacapa.

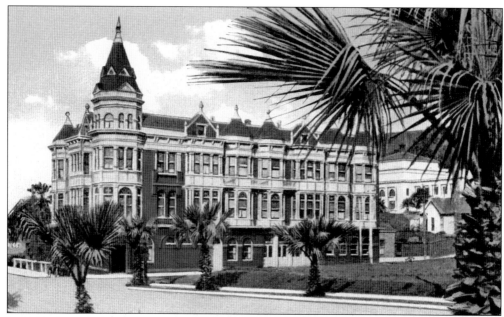

In 1913, the Hotel Rose became the Hotel DeLeon and remained a popular destination site. It was razed in 1934 and a new art deco-style building housed the Jack Rose Store, built in 1948. The Jack Rose Building eventually became the County of Ventura Public Works Department, then County Stationers, and then fell vacant for over a decade. In the late 1990s, the wrecking ball took that building down. It was replaced with retail shops and a movie theater.

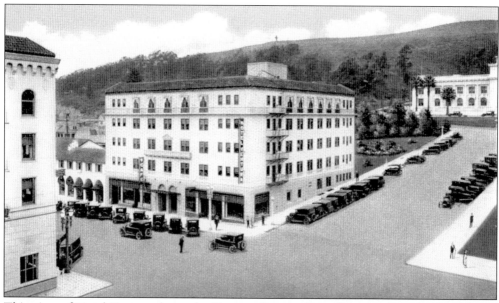

This view of Hotel Ventura shows the Ventura County Courthouse at the top of California Street and the cross on the hill beyond. For visitors coming to Ventura, this must have been an impressive site. It was close to the ocean with a wonderful bathhouse not far down the street. The gardens behind the hotel are now "planted" with buildings.

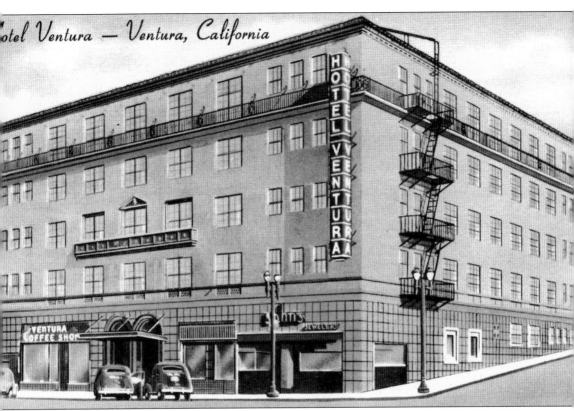

Hotel Ventura — Ventura, California

Some say there's a ghost that haunts the now-named Ventura Inn. In the 1960s, a young man hallucinating from psychedelics plunged to his death from the top of this hotel. On dark nights, people have reported a figure standing on top of the roof. This is not the only haunted hotel in Ventura. A ghost named Sylvia haunts one of the rooms in the Bella Maggiore Inn just down the street. The ghosts of George Zander has been seen in a tarot shop up the street, and city hall has several ghostly residents.

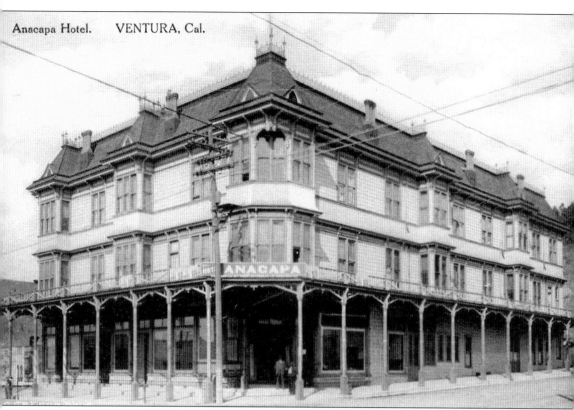

Anacapa Hotel. VENTURA, Cal.

The Anacapa Hotel was the most elaborate hotel in Ventura and was built at the height of the 1880s building boom, after the arrival of the railroad to Ventura. It was 80 feet by 130 feet, and three stories high. It had 100 "well-planned, spacious rooms, lit by electricity and furnished in fine style." The building had a mansard roof and a wraparound veranda. The proprietor and developer was Fridolin Hartman. Like the Hotel Rose, the Anacapa was a destination site for weary travelers. The hotel was torn down in the early 1930s. Controversy now surrounds this corner. The Top Hat, a very popular little hot dog joint, has stood on this corner for 40 years but is now facing the wrecking ball. An urban developer plans to build retail shops and condos on this site. As of this writing, there's an effort underway to move the Top Hat to a new location, but only time will tell. In 1984, a murder took place at The Top Hat and became the first case where DNA blood evidence was used to obtain a conviction.

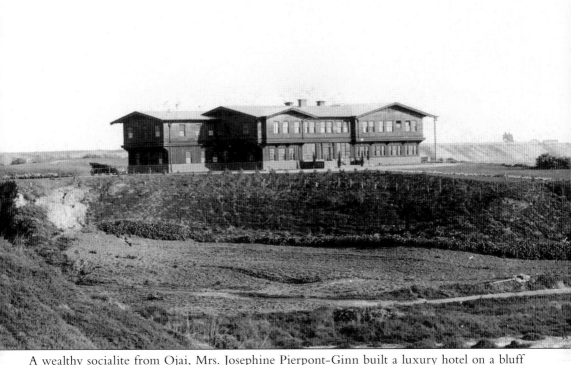

A wealthy socialite from Ojai, Mrs. Josephine Pierpont-Ginn built a luxury hotel on a bluff overlooking the Pacific Ocean for her son Austen, and for the new "motoring machines" making their way up the Coast Highway. An outstanding example of a Craftsman-style bungalow inn, the Pierpont Inn has been a Ventura landmark since 1910. The Pierpont family sold it in 1915, and the inn passed through several owners until 1928. This postcard shows one of the earliest images of the Pierpont Inn. A staircase led from the inn down the bluffs to the beach. Below the bluffs, near the bottom, today runs Highway 101. (Courtesy Cynthia Thompson.)

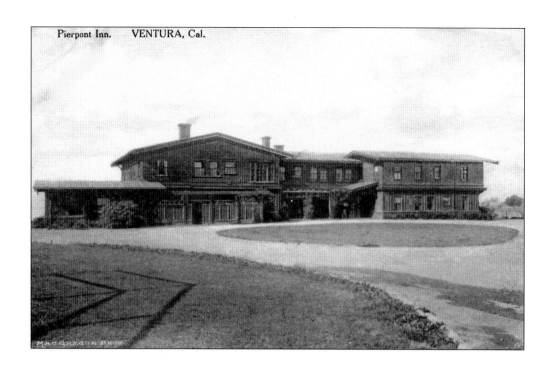

Pierpont Inn. VENTURA, Cal.

In 1928, Mattie Vickers Gleichmann, and her husband, Gus, bought the inn. The Gleichmanns worked side by side to make the inn a "home for hospitality by the sea." In 1938, Gus died a tragic death in an automobile accident. Mattie's son Ted became his mother's partner, and they continued to work together to make that dream become a reality. (Courtesy Cynthia Thompson.)

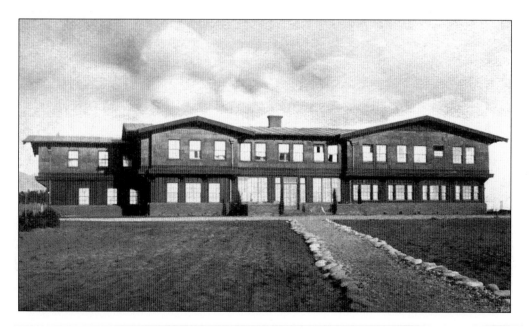

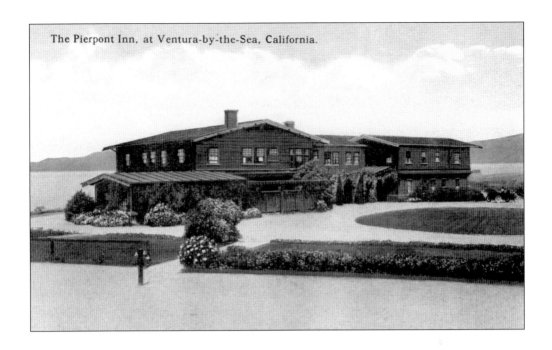

The Pierpont Inn, at Ventura-by-the-Sea, California.

A talented Filipino gardener worked with the Gleichmanns to transform the inn's gardens. His ability to grow sweet peas delighted Mattie, and she often used them for table arrangements and corsages given to mothers on Mother's Day. The message on this February 27, 1920, card reads, "We left home yesterday with glorious weather. Drove through Pasadena where we had a short visit. Came on here where we have spent the night. It's raining this morning."

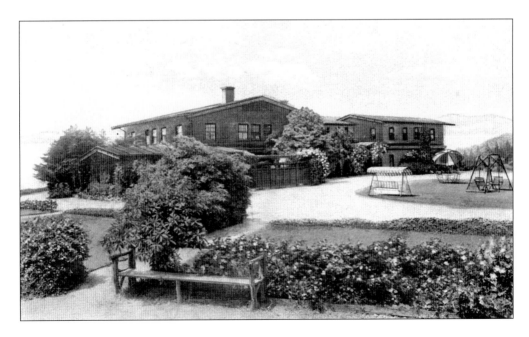

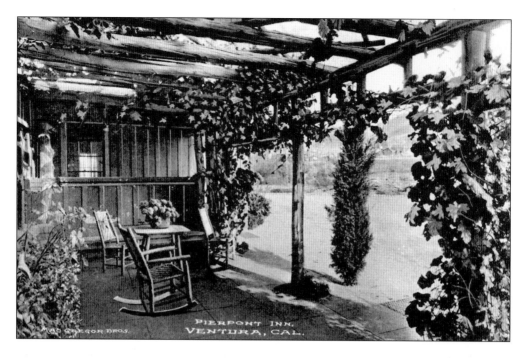

During World War II, the military took over the inn and used it for their war effort. Fortifications were established at the bluff with guns and cannons, and searchlights were set up on the grounds. Many naval officers and enlisted personnel stayed at the inn, with rank determining sleeping quarters—officers were assigned rooms while enlisted men slept in makeshift quarters in the garage. Mattie died in 1997 at almost 101 years of age. The Pierpont Inn has now passed out of the Gleichmann family hands.

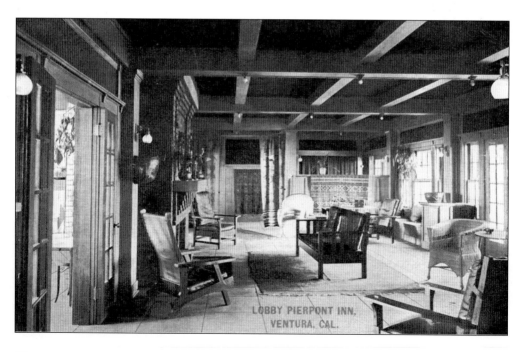

Seven

A TOWN PHYSICIAN AND EARLY SCHOOLS

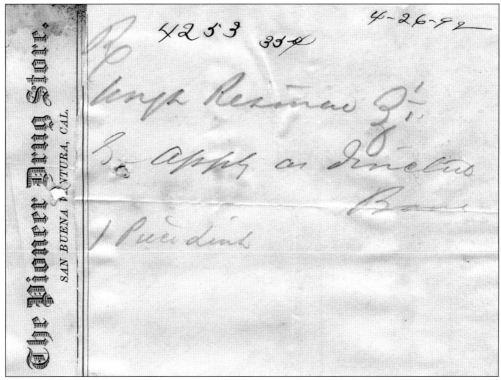

This is a rare prescription written by Dr. Cephas Little Bard, Ventura's most beloved physician. In 1868, at the urging of his brother Thomas R. Bard, Dr. Bard came to Ventura. He was the first American physician who located here. In 1900, Thomas Bard would become state senator. Dr. Bard served the county until his death in 1902.

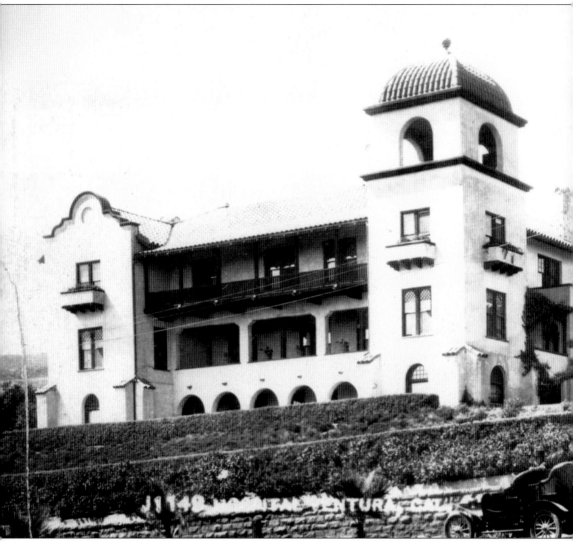

This postcard shows a very early view of the Elizabeth Bard Memorial Hospital on Poli Street. Built by Dr. Bard and his brother as a memorial to their mother, the hospital opened its doors on January 1, 1902. Designed in the Mission Revival style, it was built by well-known local builder Selwyn Shaw. The hospital featured an arched arcade, stucco surface, red-tiled roof, and

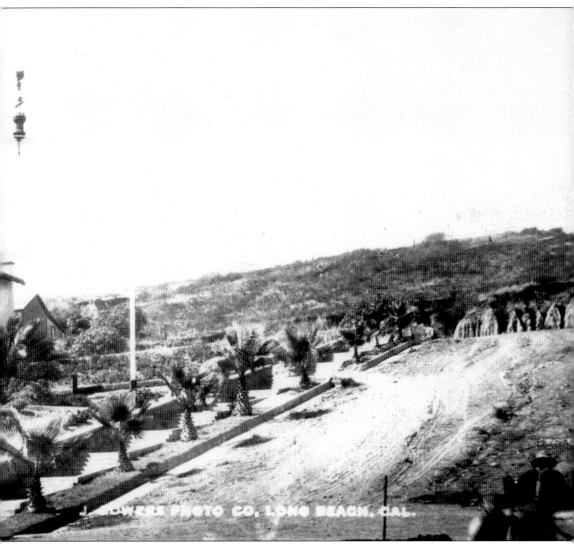

domed tower. It contained the most modern equipment of its time, skylights installed in surgical rooms, and round-corner rooms, considered to be more hygienic. It is listed on the National Register of Historic Places. The hospital later became a sanitarium, a juvenile hall, and now houses private business offices. (Courtesy John Burgman.)

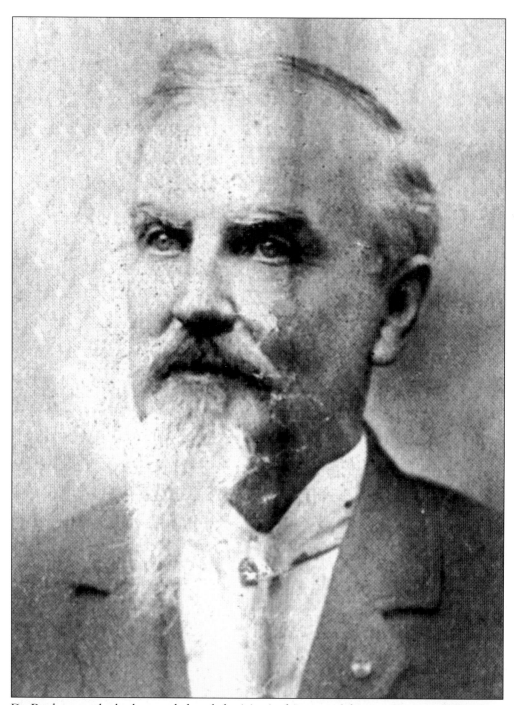

Dr. Bard was no doubt the most beloved physician in this county's history. He treated all patients equally, whether it was visiting the sickbed of a wealthy resident or riding through a rainstorm to visit the bedside of a Chumash Indian baby. Sadly, Dr. Bard was the first patient to die in his own hospital. Stricken with cancer, he died on April 20, 1902. As the mission bells tolled his death, the town prepared for the biggest funeral to ever occur. Thousands of people lined the streets, and 300 schoolchildren marched in his funeral parade.

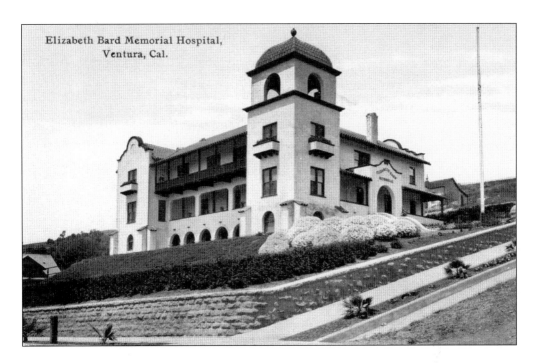

Elizabeth Bard Memorial Hospital,
Ventura, Cal.

Dr. Bard never worried about payment, often accepting items in trade, including local Chumash artifacts. In 1891, he became president of the newly formed Ventura County Pioneer Society. After his death in 1902, his collection of 300 Chumash artifacts was donated to the society. That small collection was the beginning of today's Ventura County Museum of History and Art. On July 13, 1908, this message was written on the back of the above card, "Dear Sister: Am getting along fine but not up yet. Think the Doctor will let me sit up tomorrow and hope I shall be home the last of this week. This is a lovely place and every one is nice. Lovingly, Luella."

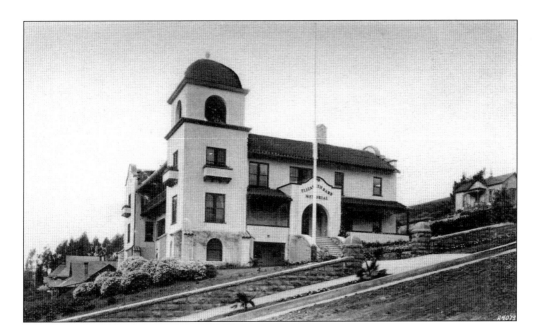

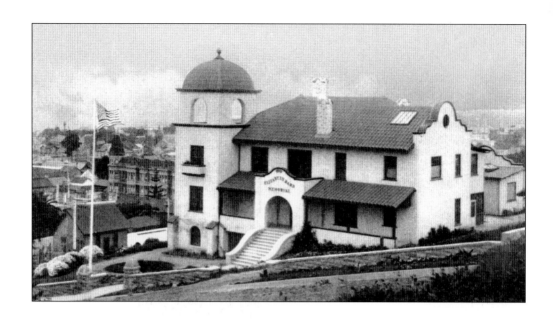

On April 23, 1902, *Ventura Daily Democrat* reported that "Dr. Bard loved the children. He was never more pleased than when receiving little tokens of appreciation from their hand, and they as well as the older folks counted on him bringing them out of all their ailments. Many a little lad and lassie are sad this day as they think that no longer can he press their little hands in his or lift them up upon his knees." Many strange things have occurred at the Bard Hospital. Over the years, people in the building have reported the faint but noticeable smell of cherry pipe tobacco—a favorite of the good doctor! And sometimes late at night, visitors on fall ghost walks report the reflection of a face in a lower window. Perhaps it's Dr. Bard waiting to welcome them inside.

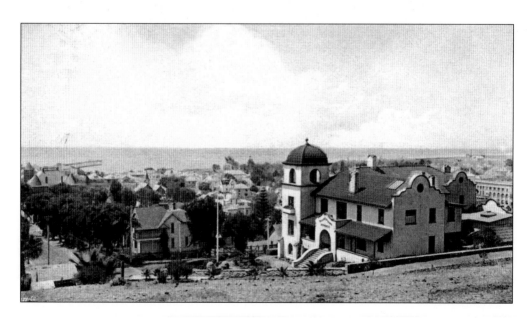

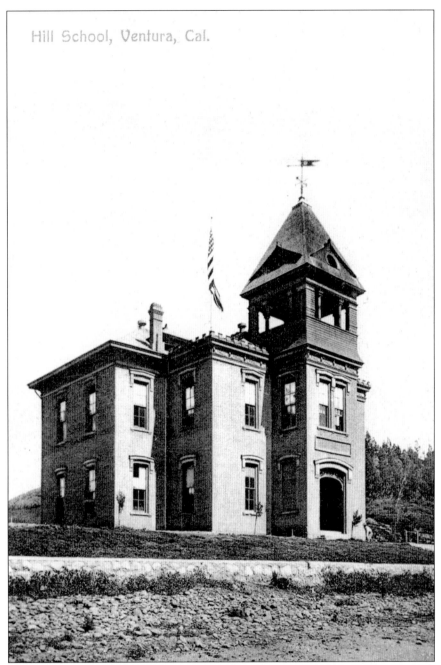

Hill School, Ventura, Cal.

Ventura's first school, designed to accommodate 40 students, was a wood-framed building built in 1866 near the intersection of Ventura and Harrison Avenues. In 1871, it was decided to build a new brick schoolhouse on Poli Street. The school, built by W. D. Hobson, cost $7,974 and had four rooms. Its opening day of March 8, 1873, was marked by a procession up the hill with banners and music. The cornerstone of the school contained a time capsule with a copy of the *Ventura Signal*, working tools of a master mason, a copy of the charter and ordinances of the town of San Buenaventura, and several other items. In 1926, Hill School was torn down. There is no mention of the whereabouts of the time capsule. (Courtesy Cynthia Thompson.)

Grammar School, Ventura, Cal.

Plaza School stood on the corner of Santa Clara and Ash Streets across from Plaza Park. Initially built as a grammar school, it soon became a combined grammar and high school. The first high school graduate was Miss Myrtle Lloyd Shepherd. The school was torn down in 1932 and replaced with the downtown post office. (Courtesy Cynthia Thompson.)

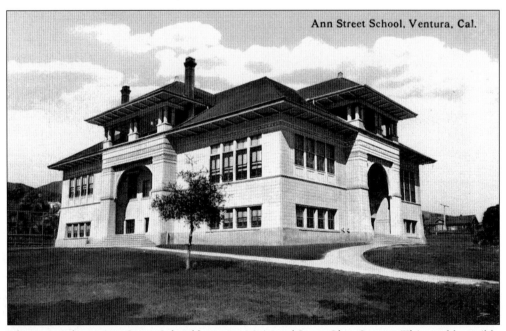

Ann Street School, Ventura, Cal.

This image shows Ann Street School between Main and Santa Clara Streets. This could possibly also be a combined grammar and high school. Similar postcards of this image have labeled it as Ventura High School. This school was eventually torn down, but another school sits on this site—Lincoln Elementary.

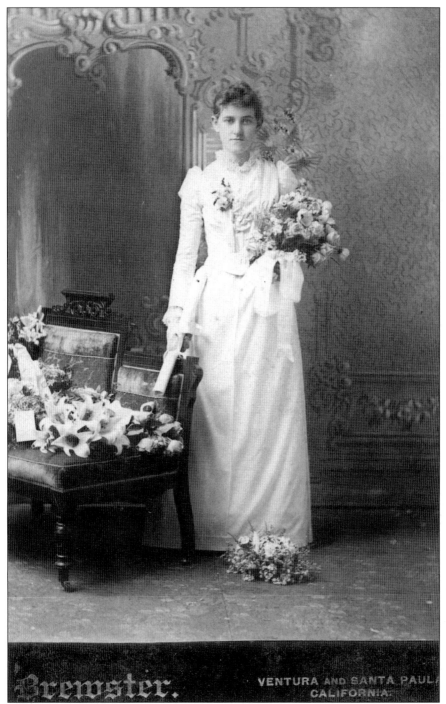

This Brewster cabinet card shows proud Ventura High School graduate Mary S. Linn in 1891. Tracking the various locations of Ventura High School has proven to be quite difficult. From 1897 until 1911, it appears to have been on Ann Street. Today it is located at the intersection of Main and Catalina Streets. Ventura has two public high schools, Ventura and Buena, and a couple private high schools.

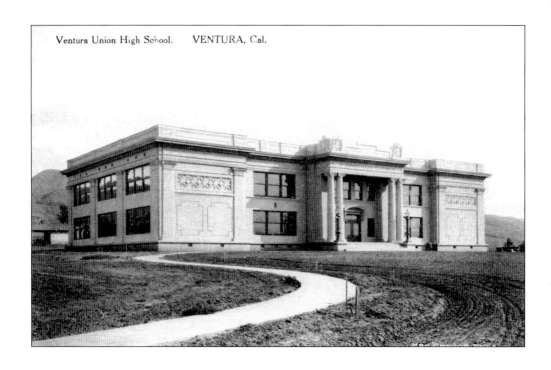

Ventura Union High School. VENTURA, Cal.

Ventura High School students finally had their own school, as depicted in these postcards. The beautiful building was located off Santa Clara Street on what is now the site of Cabrillo Middle School. (Below courtesy John Burgman.)

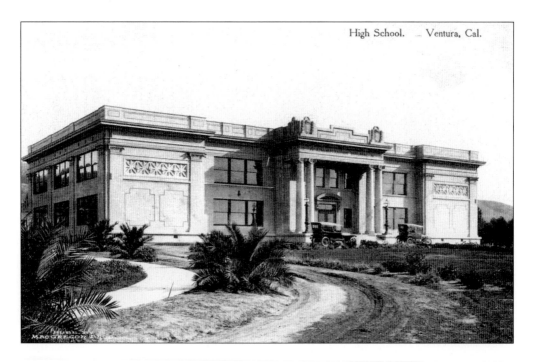

High School. Ventura, Cal.

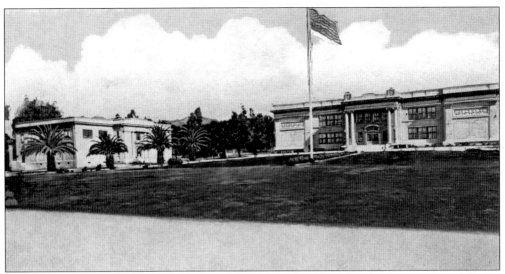

This postcard depicts Ventura High School with the new auditorium to the left behind the palm trees. Neither building exists today.

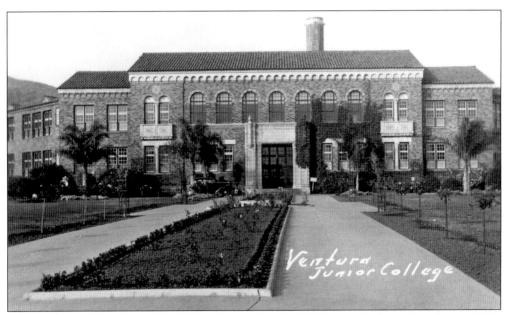

With the town's population growing, Ventura Junior College arrived on the scene in 1925. Originally sharing space in Ventura High School with grades 13 and 14, a separate wing was built in 1930. This photograph postcard is an early image of the junior college and its beautiful brick Administration Building. (Courtesy John Burgman.)

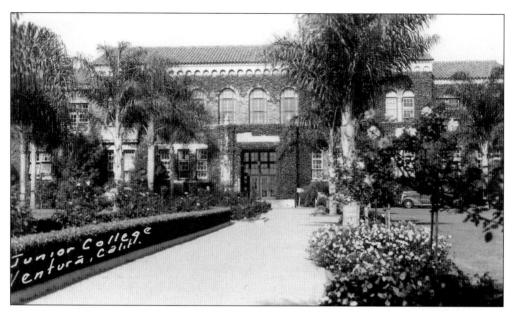

This photograph postcard taken probably a decade later shows the progress of the ivy as it creeps up the Administration Building's front wall. It must have been a stunning piece of architecture. In 1939, voters approved a bond to expand the campus. It would eventually include an agricultural laboratory, vocational arts building, auditorium, new library, social science unit, and stadium. (Courtesy John Burgman.)

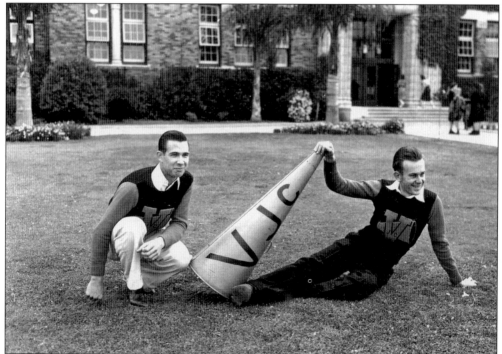

This 1939 Ventura Junior College, *La Revista* yearbook photograph shows yell leaders Homer Allen and George Cox posing in front of the school. For those of us who collect Ventura memorabilia, it sure would be nice to find an original megaphone!

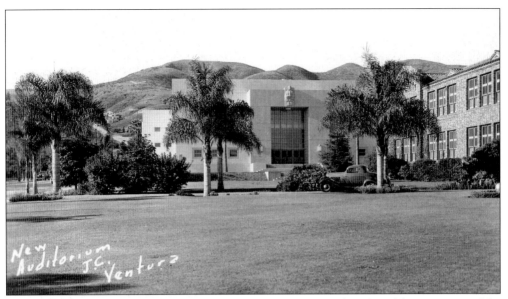

It was estimated it would take approximately one year to complete the additions approved by voters in 1939. This photograph postcard shows the high school auditorium, which still stands today at Ventura High School. The Administration Building was torn down, and Ventura Junior College eventually moved to its present site on Telegraph Road. (Courtesy John Burgman.)

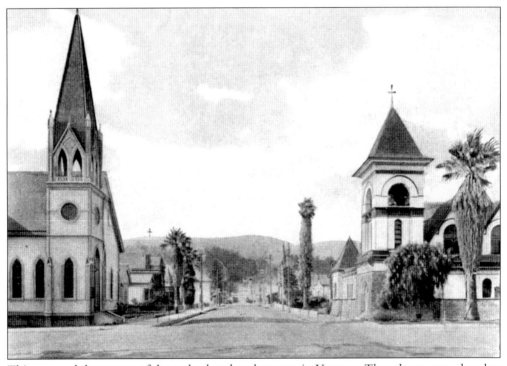

This postcard shows two of the early churches that were in Ventura. These long-gone churches were at the intersection of Oak and Meta Streets. Ventura had its fair share of churches as well as saloons. (Courtesy John Burgman.)

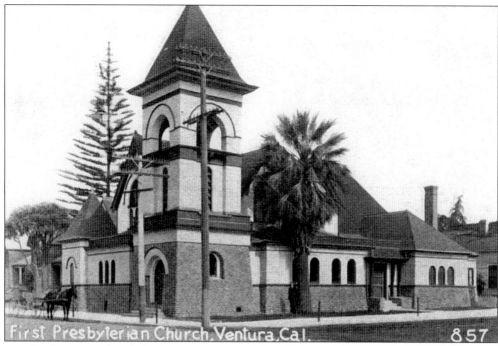

First Presbyterian Church, built in 1869 on the corner of Oak and Meta Streets, no longer exists. Below is the Methodist church, built *c.* 1869 for $2,500. Both churches are long gone, but the Presbyterian church finally found a new location on Poli. (Courtesy John Burgman.)

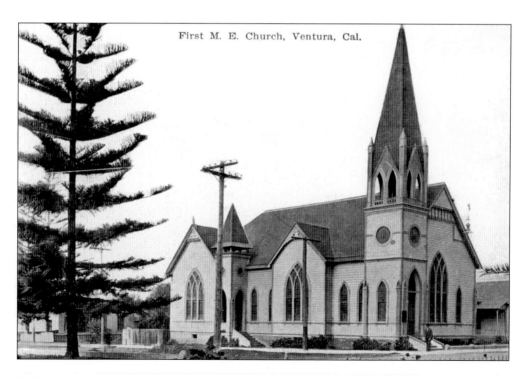

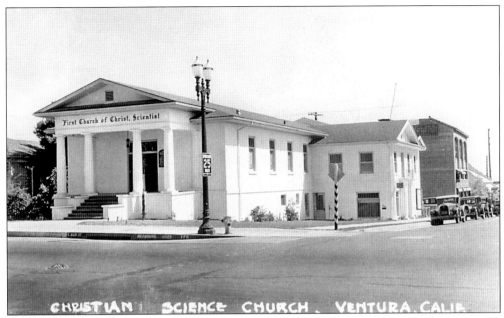

The Christian Science church on Main Street was built in 1917 and remodeled in the 1950s. The pillars were removed during the remodel. An outstanding feature is the original stained-glass windows. The building now houses business offices. (Courtesy John Burgman.)

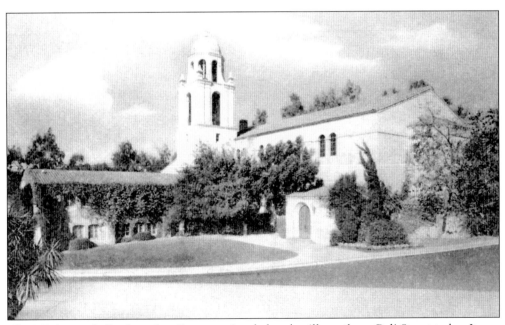

The Mission-style Presbyterian Congregational church still stands on Poli Street today. It was built in 1930 and designed by Harold E. Burket. (Courtesy Shawna Atchison.)

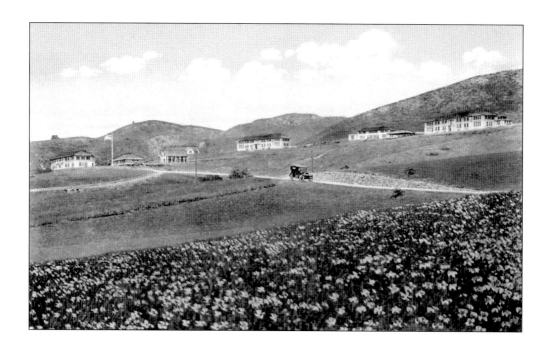

The infamous Ventura School for Girls was built in 1913 off Ventura Avenue on the outskirts of town. Its first residents were transferees from the Whittier State Reformatory. The school had a horrible reputation as a hellhole. During the Zoot Suit Riots of 1943, four Latinas were taken into custody in Los Angeles and sent to the school. According to historian Elizabeth Escobedo, "Young women would go to very drastic measures in order to escape going to the Ventura School for Girls. There were women at the juvenile hall who . . . were swallowing safety pins the night before in order to get out of it." In 1962, the Ventura School for Girls was moved to a location in Camarillo. This Ventura location has been a psychiatric facility since then.

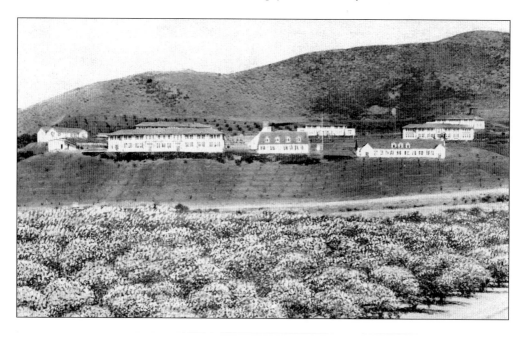

Eight

ALL ABOARD

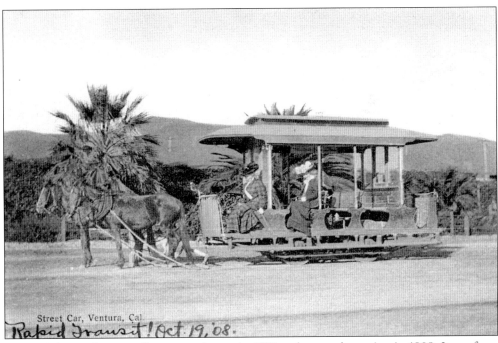

Street Car, Ventura, Cal.

Rapid Transit! Oct. 19, '08.

Ventura's horse-drawn trolley system began in 1891 and stopped running in 1908. It ran from the train depot on Front Street to just beyond the mission, and consisted of two trolleys. In 1908, residents thought they'd seen the last of the trolleys. The morning after Halloween one trolley was found floating in the surf and the other was lying in the sand at the end of Chestnut Street with all its windows broken out. Some say residents were glad to see them gone.

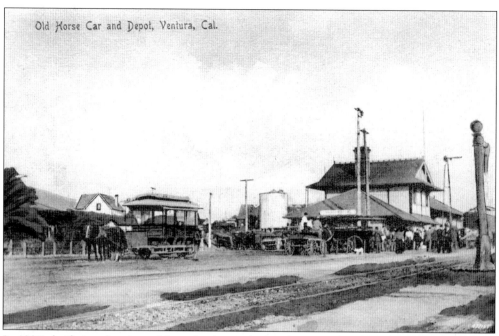

Old Horse Car and Depot, Ventura, Cal.

In 1887, the first train steamed into the depot. A cheering crowd and brass band were on hand for this much-awaited day. Ventura's first station agent was John Simpson. With the arrival of the train, Ventura experienced its second building boom. Streets were graded, hotels built, sidewalks laid out, and the town's first theater built. It was also at this time that the name San Buenaventura was shortened to Ventura. San Buenaventura was too large to fit on time tables and destination boards. The official name still remains San Buenaventura. In 1973, the Southern Pacific Railroad abandoned the depot and tore it down—a very unfortunate decision. (Below courtesy Cynthia Thompson.)

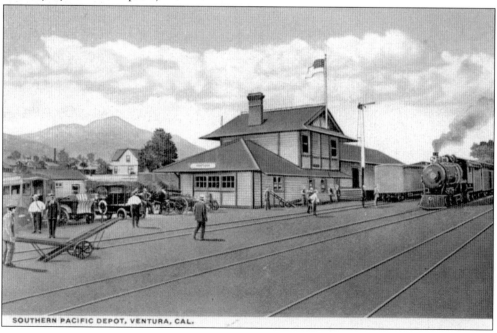

SOUTHERN PACIFIC DEPOT, VENTURA, CAL.

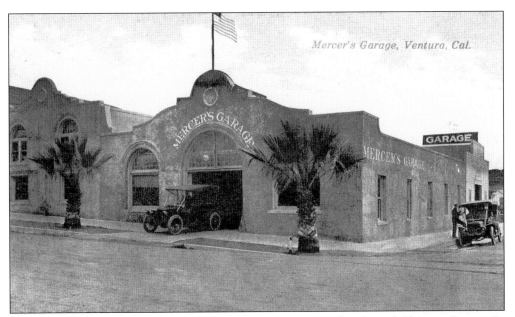

This postcard shows the old Mercer's Garage on the corner of Main and Chestnut Streets. In 1906, Sheriff McMartin was given the first sheriff's car and Ed Mercer served as his official driver— since not many people in town knew how to drive the "new motoring machines." (Courtesy Dena Mercer.)

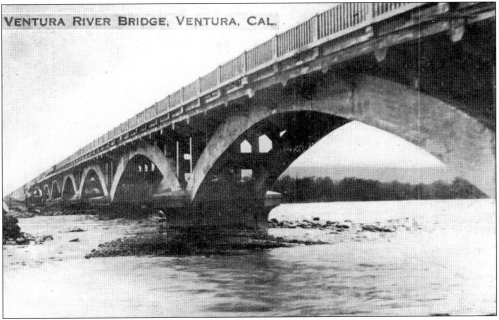

In 1913, the Ventura River Bridge and Rincon Road were opened with a large celebration. On the Fourth of July, a big parade marched down Main Street, crossed the bridge, and came back. The stretch of coastline between Ventura and Santa Barbara was named El Rincon, meaning corner or nook. Before the road was built, travel in and out of Ventura was difficult with travelers waiting for low tide in order to ford the river. A long circuitous route over the Casitas Pass could be taken, but it was very bumpy and uncomfortable.

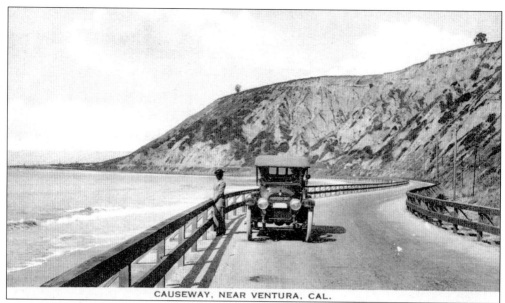

CAUSEWAY, NEAR VENTURA, CAL.

On April 27, 1906, the *Ventura Weekly Democrat* reported that "Being on the great highway between San Francisco and Los Angeles, Ventura is destined to witness the passage of more automobiles of all varieties and descriptions than any place on the coast. It is the one town the machines are compelled to pass through whether they would or no, there is no other choice left them." (Courtesy Cynthia Thompson.)

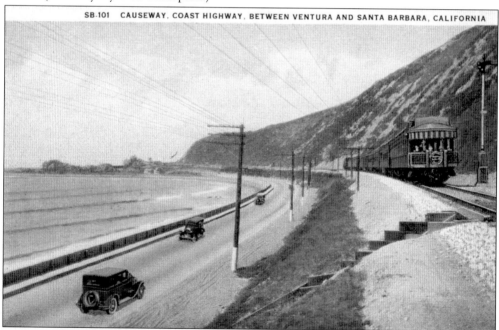

SB-101 CAUSEWAY, COAST HIGHWAY, BETWEEN VENTURA AND SANTA BARBARA, CALIFORNIA

A series of raised wooden causeways was the first Rincon hugging the shoreline, eventually replaced with paved road. Highway 101 came through in the 1960s, and the old Rincon Road is now used by weekend campers and tourists to relax or just watch the sunset. It was fun in the late 1950s driving to Santa Barbara, because at high tide the waves would crash over the sea wall and spray cars with water. (Courtesy John Burgman.)

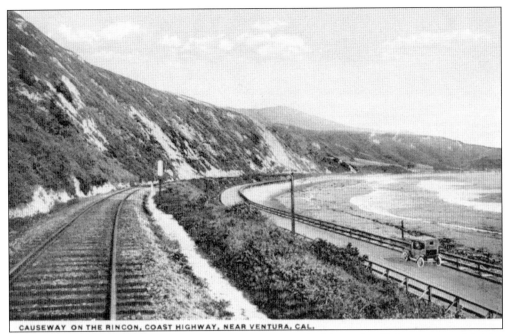

CAUSEWAY ON THE RINCON, COAST HIGHWAY, NEAR VENTURA, CAL.

Much as it was in its early days, the highway remains a scenic drive today. Drivers can see dolphins frolicking in the surf and pelicans diving for their dinner on any given day. After a rain storm, the view of the Channel Islands is breathtaking.

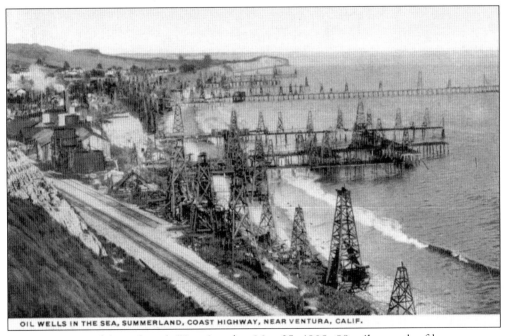

OIL WELLS IN THE SEA, SUMMERLAND, COAST HIGHWAY, NEAR VENTURA, CALIF.

The message on this card read, "Los Angeles, May 25, 1908: 98 miles north of here, we pass through here on our way to San Francisco by the Southern Pacific Railroad Coast Line." The site of so many oil derricks along this stretch of coastline must have been very impressive for travelers by train.

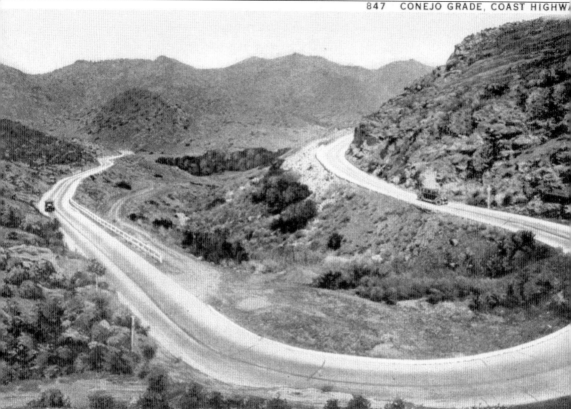

104181

Motorists today traveling up and down the Conejo Grade do not realize how perilous this route was in the late 1800s. Nothing more than a steep mountainous pass, it was very difficult to travel by stagecoach. Often weary stagecoach passengers had to get off and walk part-way down the hill to prevent runaway stages caused by the weight of passengers and luggage. Once the stagecoach got to the bottom and made its way closer to Ventura, the Santa Clara River had to be forded. Not an easy task when the river was known to run swift and fast with the occasional pit of quicksand.

110

Nine

AGRICULTURE, OIL, AND THE AMERICAN DREAM

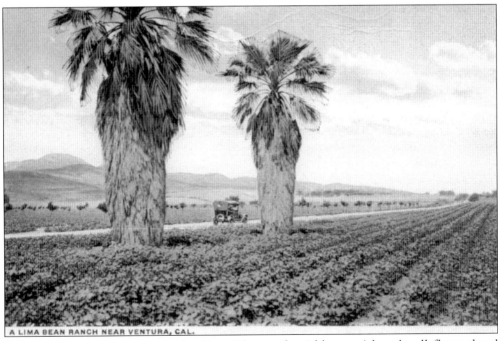

A LIMA BEAN RANCH NEAR VENTURA, CAL.

"The best beans ever grown are the Lima. They cool quickly, are rich and well-flavored and command double the price in the New York market of any other bean. They are a vine or pole bean, but in this dry climate do not require to be poled. Cooked for a couple of hours with a piece of bacon or pork, they make a dish that any epicure would highly prize. Just try them," reported the *Ventura Signal* on February 8, 1872. (Courtesy John Burgman.)

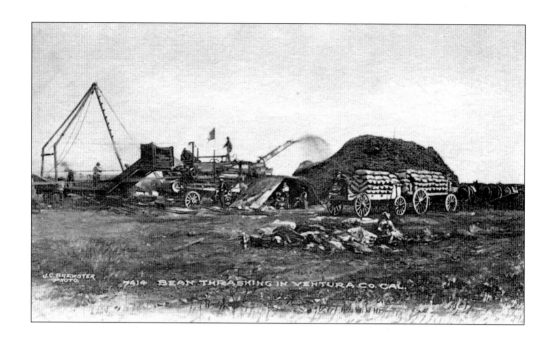

Ventura County has been called the "Bean County of the Nation," with 50,000 to 60,000 acres planted in the county during the early 1900s. The bean threshing machine was an adaptation of the wheat threshing machine. After the beans were dried in the field, they were hauled to the thresher, threshed, and then sacked. The lima bean brought millions of dollars to Ventura County's economy. Strawberries are now the county's largest cash crop.

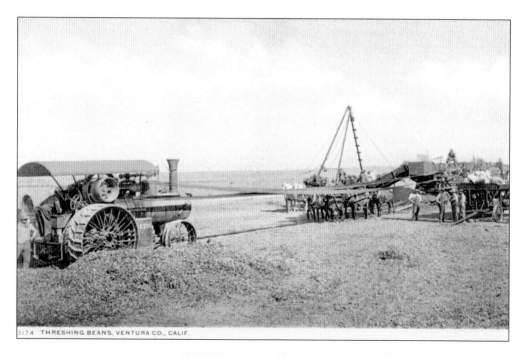

THRESHING BEANS, VENTURA CO., CALIF.

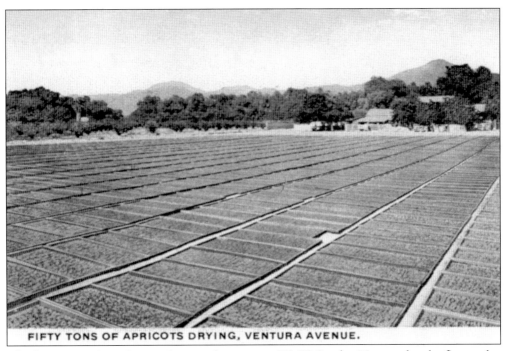

FIFTY TONS OF APRICOTS DRYING, VENTURA AVENUE.

The first man to introduce apricots to the area was W. W. Sparks. He was also the first to dry them for market. Various methods for drying the fruit were tried, but with many failures. Eventually the easiest way was to allow the fruit to dry in the orchards where they were grown and then spread them on wide trays in the sun. (Courtesy John Burgman.)

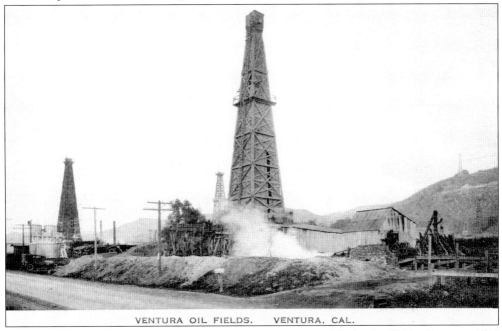

VENTURA OIL FIELDS. VENTURA, CAL.

This wooden oil derrick on Ventura Avenue was a common sight in the 1920s. Between 1916 and 1922 numerous oil companies tried to find successful oil deposits up the avenue. It wasn't until 1922 that the fields began producing large amounts of the black gold.

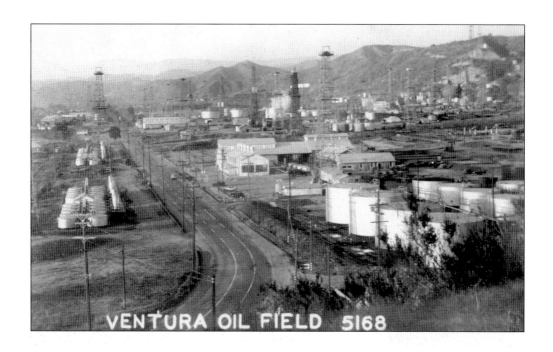

VENTURA OIL FIELD 5168

The growth of the Ventura Avenue oil field continued to increase along with oil production. Production of barrels of oil in December 1929 was 1,889,245 and averaged 60,943 barrels per day. A barrel contained 42 gallons of oil. Shell Oil Company had 185 active producing oil wells on the avenue at that time. These dense oil fields are a thing of the past. (Above courtesy John Burgman.)

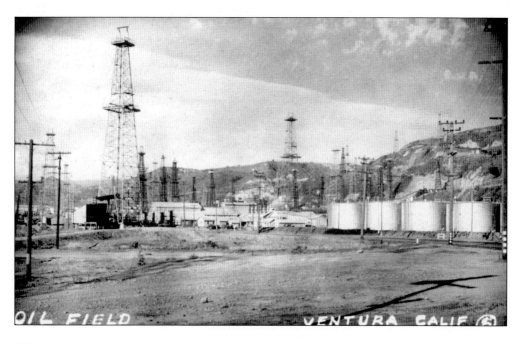

OIL FIELD VENTURA CALIF

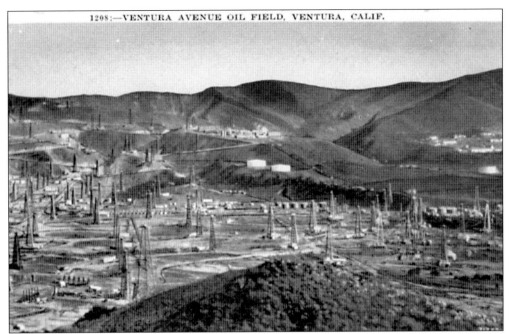

The first well for oil was drilled in Ventura County in 1865 near Ojai; it was also the first well in California. In 1890, the Union Oil Company was formed, but it wasn't until a brush fire in the back hills of Ventura that the rich oil deposits of the avenue were discovered. It wasn't magic that fed the flames, it was the escaping gas from the rich oil deposits below. (Courtesy Cynthia Thompson.)

This *c.* 1909 photograph shows the James Allen Day house on Poli Street. J. A. Day arrive in Ventura in 1874 and built a farmhouse on (now) Telephone Road. He planted 100 acres of apricots and created the first fruit dryer in the county. He retired from farming and moved to his "lovely house overlooking the town and ocean." The farmhouse on Telephone Road is boarded up and in a state of deterioration.

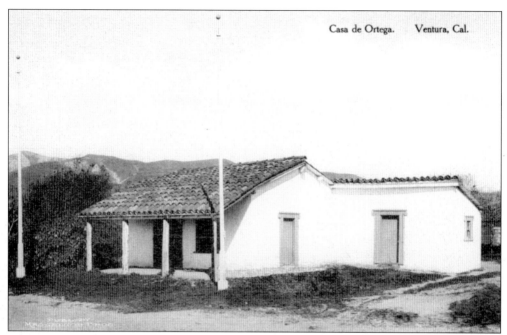

The Ortega Adobe at 215 West Main Street was built in 1857 by Emigdio Ortega. In this small, three-room adobe, the Ortegas raised their 13 children. The flood of 1862 wiped out half of the adobe, but it was rebuilt using original roof tiles from the mission. In 1897, the Ortega Chili Company got its start here. At other times it has been a saloon, a Chinese laundry, a pottery shop, a speakeasy, VFW hall, employment office, police station, and a boys and girls club. It is now a historic landmark.

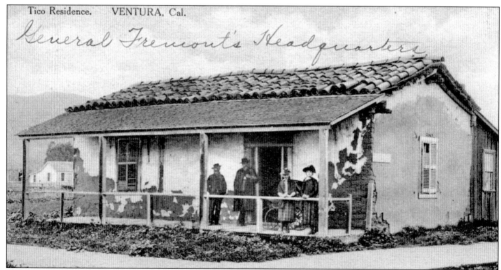

According to the *Ventura Free Press* on May 1, 1903, "there was a time when the old adobe structures on lower Main Street were considered palatial. They were not alone the finest houses in San Buena Ventura, but in the county as well. Later these structures, with the coming of the Americans and progress, gave way to residences and buildings of modern design and workmanship." The Tico Adobe was on the corner of Main Street and Ventura Avenue. Burger King occupies that location now.

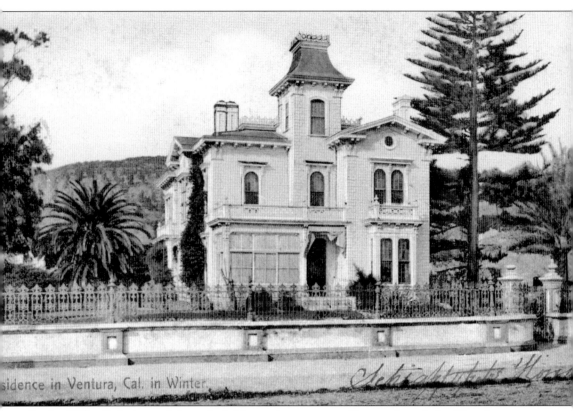

sidence in Ventura, Cal. in Winter.

In the 1850s, Federico and Antonio Schiappapietra came to Ventura from Italy. They became wealthy businessmen and, in 1876, built this 18-room Italian villa on Santa Clara Street. With extensive gardens, it featured a square tower with mansard roof, bay windows, balconies, and fancy roof crestings with wrought iron fencing around the property. The interior featured a sweeping staircase and white marble fireplace with an eight-foot mirror above. Cherubs and angels in plaster relief decorated the high ceilings. The mansion was torn down in 1953 to put in (what else) a parking lot next to Landmark 78 restaurant—the Carlo Hahn house.

This photograph shows the Mercer home, adjacent to Mercer's Garage on North Chestnut Street. It was a time when homes were custom built and no two homes, even if built side by side, were alike—a far cry from today's cookie-cutter housing developments. The home no longer exists. (Courtesy Dena Mercer.)

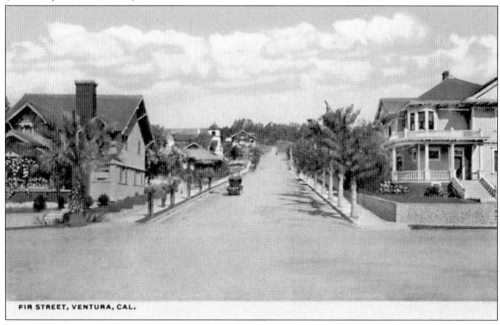

FIR STREET, VENTURA, CAL.

This image shows Fir Street looking up from Main Street toward Poli Street. The large house on the left still exists and today is Emma's Herbs. The large house on the right has been extensively altered and is now an eatery called Bernadette's. (Courtesy Cynthia Thompson.)

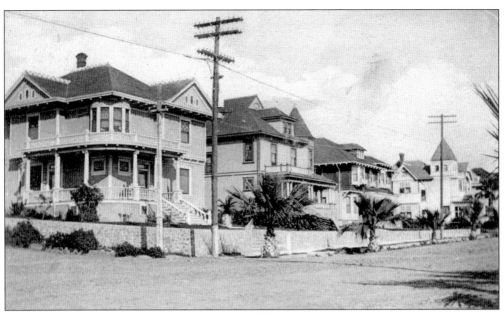

This is Main Street looking east from Fir Street. The house on the corner is original to the site, although altered and now Bernadette's. The second house is the elaborate 1905 Queen Anne home of Capt. David Blackburn, an early Ventura pioneer and Civil War veteran. It features a wraparound porch, double Corinthian columns, and narrow clapboard siding with a turret on the second floor. Much of the interior of the home remains unaltered. For many decades it has been the law offices of Taylor and McCord. It is now up for lease, and is also said to be haunted by the ghost of Captain Blackburn.

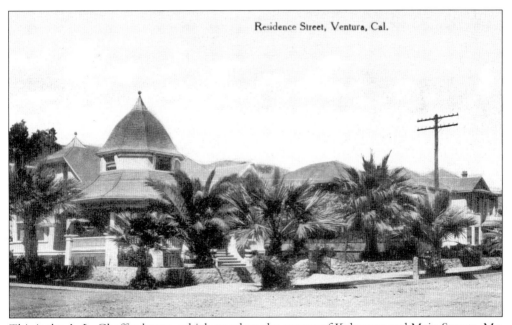

This is the A. L. Chaffee house, which stood on the corner of Kalorama and Main Streets. Mr. Chaffee was owner of A. L. Chaffee, a large mercantile in Ventura. The house was moved at one point to a different location, but eventually torn down.

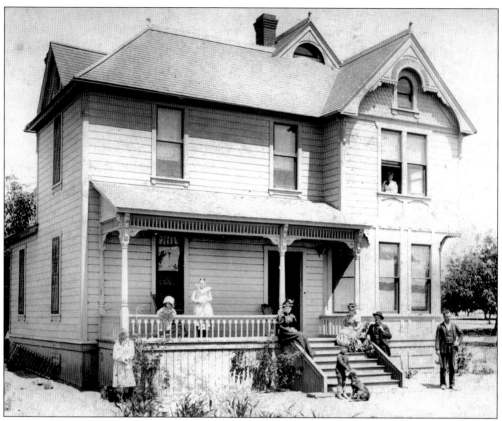

The Dudley House was built in 1892 and stood on Telegraph Road near the intersection of Ashwood (where Carrow's Restaurant stands). It is an outstanding example of the simple farmhouses that once dotted Ventura in the late 1800s. Moved to its present location near Loma Vista, the house has been restored by San Buenaventura Heritage, Inc. It is open the first Sunday of each month for house tours. (Courtesy San Buenaventura Heritage, Inc.)

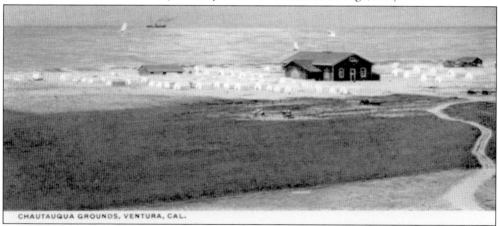

The Chautauqua Society was a traveling revival show of sorts and offered entertainment in their fine pavilion during the summer. It was described as a well-organized association, and the pavilion seated 1,500 people. This was located in the present-day Pierpont Bay area. (Courtesy Cynthia Thompson.)

Ten

ALONG THE
COAST HIGHWAY

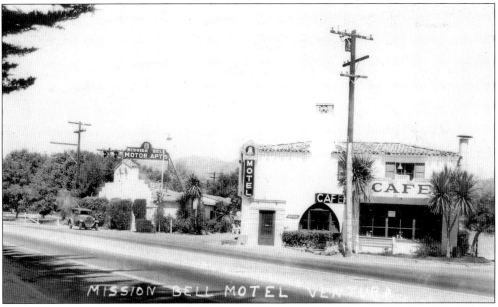

Travelers heading up the Pacific Coast drove through the heart of Ventura along Business District 101. One of the first motor lodges seen would have been the quaint Mission Bell Motel, located at 3237 Ventura Boulevard (U.S. Highway 101, now Thompson). This *c.* 1940 postcard describes the Mission Bell Motel as "rooms with and without kitchenettes. 'Ventura's Finest' Close to the beach, Cafe in connection. All rooms completely furnished. Beautyrests. Tile showers. Steam heat." While the motel exists in the same location, the Mission Bell Cafe closed down several years ago. That space is now a tile store. (Courtesy John Burgman.)

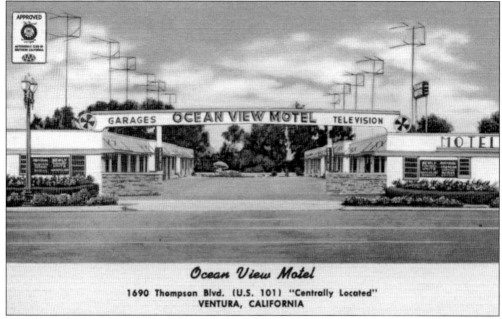

Ocean View Motel

1690 Thompson Blvd. (U.S. 101) "Centrally Located"
VENTURA, CALIFORNIA

The Ocean View Motel was located at 1690 East Thompson Boulevard. It featured 17 nicely furnished, redecorated units with full-tile baths—tubs or tile showers, television and radios in every unit, panel-ray heat, garages, and wall-to-wall carpeting. Some also offered kitchenettes.

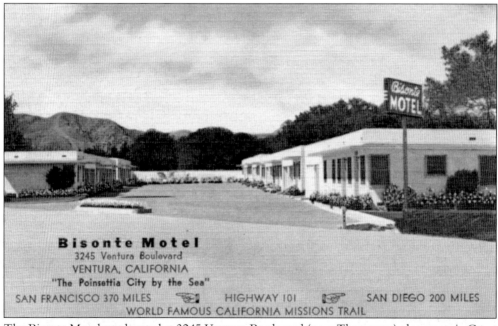

Bisonte Motel

3245 Ventura Boulevard
VENTURA, CALIFORNIA

"The Poinsettia City by the Sea"

SAN FRANCISCO 370 MILES HIGHWAY 101 SAN DIEGO 200 MILES
WORLD FAMOUS CALIFORNIA MISSIONS TRAIL

The Bisonte Motel was located at 3245 Ventura Boulevard (now Thompson) along scenic Coast Highway 101. It had large gracious rooms with tile showers, radios, garages, and panel-ray heat. When the freeway was built in the 1960s, Ventura was all but forgotten. No longer did people drive through the heart of town, but instead passed it by.

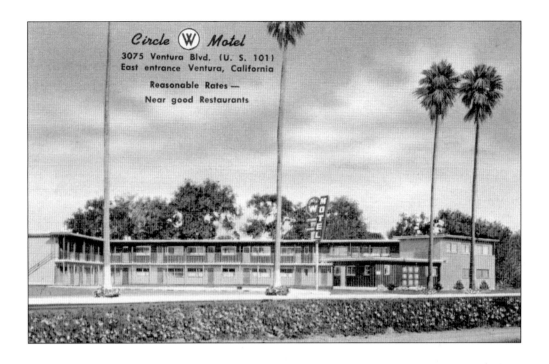

The Circle W Motel at 3075 Ventura Boulevard and Silver Spruce Motel were also located on U.S. Highway 101. The Circle W featured reasonable rates and was located near "good" restaurants. (Both courtesy John Burgman.)

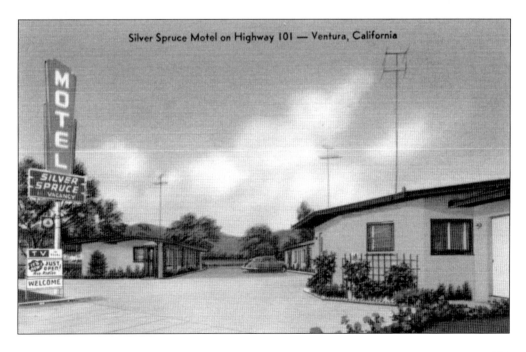

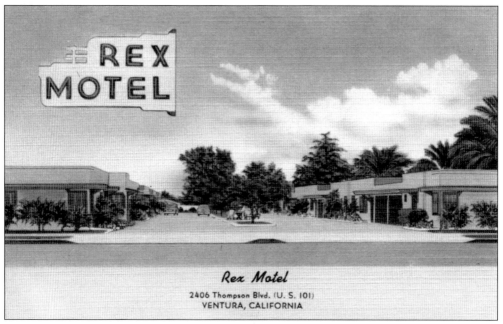

Rex Motel
2406 Thompson Blvd. (U. S. 101)
VENTURA, CALIFORNIA

The Rex Motel, located at 2406 Thompson Boulevard, was an 18-unit, fully modern motel with wall-to-wall carpet, tile showers, panel-ray heat, garages, radios, televisions, and some kitchens. The Rex Motel also boasted of good restaurants nearby.

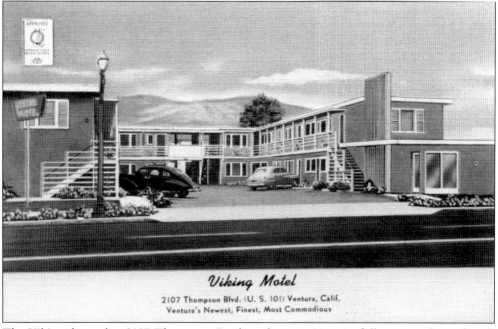

Viking Motel
2107 Thompson Blvd. (U. S. 101) Ventura, Calif.
Ventura's Newest, Finest, Most Commodious

The Viking, located at 2107 Thompson Boulevard, was a 16-unit, fully carpeted motel with panel-ray heat and combination tub and shower. Rooms contained radios and some kitchenettes with "call" service.

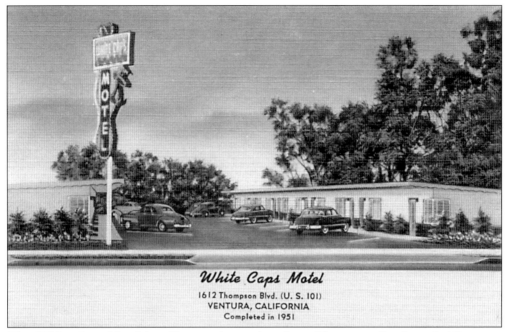

White Caps Motel
1612 Thompson Blvd. (U. S. 101)
VENTURA, CALIFORNIA
Completed in 1951

The White Caps Motel is still operating today along Thompson Boulevard. (Courtesy John Burgman.)

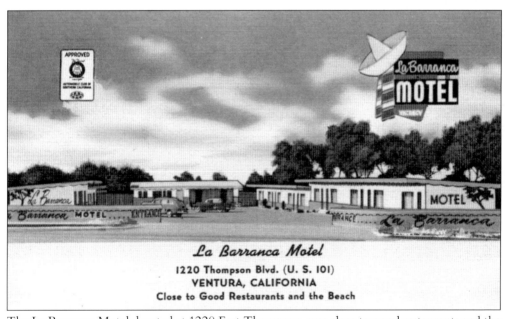

La Barranca Motel
1220 Thompson Blvd. (U. S. 101)
VENTURA, CALIFORNIA
Close to Good Restaurants and the Beach

The La Barranca Motel, located at 1220 East Thompson, was close to good restaurants and the beach. This new 20-unit motel had rooms with full-tile, glass–door showers, panel-ray heat, wall to wall carpets, radios, televisions, and call service. (Courtesy Cynthia Thompson.)

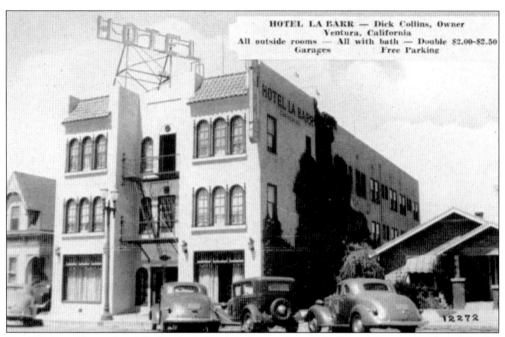

Hotel LaBarr, located at 239 South California Street, featured all outside rooms, all with baths. A double room cost $2 to $2.50, and this hotel featured garages. It no longer exists. (Courtesy Shawna Atchison.)

This long-standing building near the intersection of today's Thompson Boulevard and California Street was Blair's Cafe, specializing in seafood and charcoal broiled steaks. It was also an upscale restaurant called BJ's Steakhouse. It is now Cooper's Cafe. (Courtesy Cynthia Thompson.)

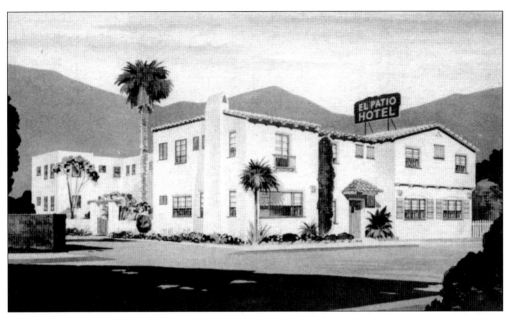

The El Patio (Spanish for courtyard) was another of the finest hotels for motorists along the coast. Built in the late 1920s, this hotel is still located on South Palm Street in Ventura. (Courtesy Michel Colmache.)

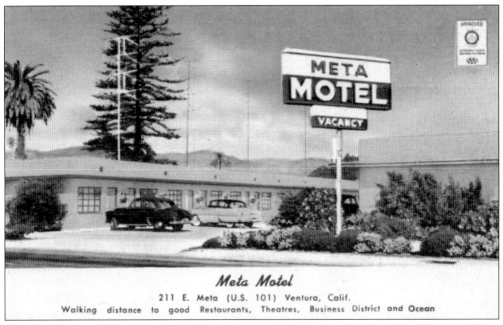

The Meta Motel was located at 211 East Meta Street. It is now abandoned and slated for demolition as part of another downtown redevelopment project. (Courtesy Shawna Atchison.)

BIBLIOGRAPHY

I have used many old newspapers and publications to compile information for this book. Some detail is very sketchy, and in researching, I found conflicting information depending on which version or decade I used. So, while I have tried to be as accurate as possible, the captions are only as accurate as my available sources. If there are factual errors, I welcome the correct information. My e-mail address is: venturahistorian@aol.com.

Annual Report of the County Auditor, Ventura County, California. 1907–1908.

"Cañada Larga: History and Preservation of the Mission San Buenaventura Aqueduct."
 Ventura County Historical Quarterly. 1987.

Daily Free Press, 1908.

Ellis, Mark. "Poor Man's Justice: Vicente Garcia and the Nineteenth Century California
 Justice System" *Ventura County Historical Quarterly.* 1994.

The First 100 Years in Ventura. Souvenir centennial publication. 1966.

Historical walking tour brochure. City of Ventura, 1980s.

Historical walking tour guide. Ventura County Museum of History and Art.

Hobson, Edith and Myrtle Shepherd Francis. *A Romantic History of San Buenaventura.* 1912.

Johnson, John R. "Ventura's Chumash Community in the early 1880s." *Ventura County
 Historical Quarterly.* 1994.

Kurillo, Max and E. M. Tuttle. *The Mission Bells that Never Ran.* 1995.

Mission San Buenaventura, One Hundred and Seventh-Fifth Anniversary. 1782–1957.

Murphy, Arnold. *A Comprehensive Story of Ventura County, California.* 1979.

"Public Library Service in Ventura: A Brief History." *Ventura County Historical Quarterly.* 1983.

Senate, Richard. *Erle Stanley Gardner's Ventura.* Walking tour guide.

Sheridan, Sol. *History of Ventura County.* 1926.

Souvenir brochure, 1902. San Buenaventura Fire Department, reprinted 1980.

Standard Oil bulletins. 1929 and 1930.

The Story of Ventura County. Title Insurance and Trust Company, 1956.

"Theodosia Burr Shepherd, California's Pioneer Floriculturalist." *Ventura County Historical
 Quarterly.* 1963.

"Ventura County, California." *Sunset Magazine.* 1909.

Ventura Democrat (illustrated edition) for St. Louis Worlds Fair. 1904.

Ventura Signal. 1872, 1875, 1876.

The Ventura Story. City of San Buenaventura, 1966.

Ventura Weekly. 1903.

Ventura Weekly Democrat. 1906.

Wheeler, Eugene D. and Robert E. Kallman. *Shipwrecks, Smugglers and Maritime Mysteries.*
 1989.